CAREER DIARY™

OF A

PHOTOGRAPHER

Thirty days behind the scenes with a professional.

GARDNER'S CAREER DIARIES™

BARBIE PERKINS-COOPER

GARTH GARDNER COMPANY

GGC publishing

Washington DC, USA · London, UK

Editorial inquiries concerning this book should be mailed to: The Editor, Garth Gardner Company, 5107 13th Street N.W., Washington DC 20011 or emailed to: info@ggcinc.com.http://www.gogardner.com

ISBN-13: 978-1-58965-047-3

Library of Congress Cataloging-in-Publication Data

Perkins-Cooper, Barbie.
 Career diary of a photographer: 30 days behind the scenes with a professional / Barbie Perkins-Cooper
 p. cm. . (Gardner's career diaries)

ISBN-13: 978-1-58965-047-3

1. Photography—Vocational guidance. 2. Perkins-Cooper, Barbie. 3. Photographers—United States—Diaries. I. Title.
ML3798.S428 2008
793.5344--dc22
 2007014986

Printed in Canada

TABLE OF CONTENTS

BIOGRAPHY

I confess, photography has been a passion of mine for all of my life. As a toddler, I was a clown, posing to make silly images for my father, never recognizing how important photography would become in my life. I'll never forget the first time I played with a camera, an old Kodak Brownie borrowed from my father. The same camera he used to capture images of his children when my three sisters and I were clowning around or misbehaving.

A few years later, I found the Brownie camera packed away in a box of old items labeled trash after my parent's divorce. I rescued the camera, keeping it under my bed, remembering the times when Dad would click the shutter while I giggled and posed. We lived in Atlanta, Georgia at the time. I was thirteen when a friend of a friend was looking for someone to photograph her son's rock band. Stepping up to the plate, just to have something to do, I volunteered, failing to realize how much I would enjoy capturing images on film.

When I was fifteen, another friend praised my photographs, encouraging me to pursue photography as a career. What did she know, I said to myself, filled with starry dreams of my life as a singer or an actress. Later she mentioned she had volunteered my services to take photographs of another rock band, a local group in Atlanta, Georgia named the Ravens. When the band saw the photographs they raved about how good the images were, along with the

personalities and charisma I had captured. I brushed it off. After all, I was only fifteen years of age. What did I know about photography? Four months later, three of the black and white photographs of The Ravens saw publication in a national news publication. Unfortunately, I failed to get a copy of the magazine and a member of my family destroyed all of the photographs. Thus began my life and vocation as a photojournalist. I would tinker with this passion off and on for many years.

In high school, I photographed football games, dances and other events. After marriage, I took photographs of neighborhood children and my son, the Cub Scout camp outs, and other occasions, although I failed to pursue photography as a career. The rat race of life dictated my time until I became a professional writer and photojournalist.

In 1988, serving as the communications officer at the Charleston Campus of Johnson & Wales University, my passion for photography returned. I found myself taking photographs of special events, graduations, food festivals, and other commemorative events on campus. Many of these photographs were so impressive they were published in local and national publications. All were considered work for hire, so I did not list them on my resume, nor did I save any of the photographs for my files. Dedicating fifteen years to the hospitality industry at Johnson & Wales, I managed to pick the brains of professional food stylists and photographers, discovering a few tricks of the trade. While I do not promote myself as a professional food stylist, many of my photographs of culinary cuisine made publication.

In 1994, my photojournalism talents opened a few doors when several stories and photographs were published in newspaper publications. Cover photographs credits include *Construction Equipment Guide* and *Hard Hat News*. Regional published photographs made inclusion in periodical stories I wrote for *Easy Street*, and *Carolina Magazine* and *Southern Hospitality Magazine*. Later, I ventured into travel writing and photography. Attending a travel writer's workshop in 2004, I decided it was time to target travel publications, since I knew much about hospitality, food and wine, luxury hotels, and travel after working in the hospitality industry. I was certain I could meet the challenge.

When my career at the Charleston Campus was downsized, due to the school relocating to Charlotte, North Carolina, I chose to open a window of opportunity in photojournalism. Armed with a 35mm camera, I submitted many stories and images to publications, signed a contract for a guidebook, and created a website. Recent travel articles include stories and photographs in *Hair and Beauty Magazine*, *Kentucky Monthly*, *Southern Hospitality*, and I target food and wine publications.

In 2001, I published, *Condition of Limbo*, a memoir, based on my father's terminal illness and death. The cover photograph displayed a powerful sunset photograph, listing me as the photographer.

In 2005, my husband gave me a digital camera and I discovered the world of instant imagery. Digital photography continues to advance and most of the publications I work for

prefer the resolutions of digital. I own a Canon Rebel Digital and Nikon D-50 and use both of them when I schedule professional shoots.

In August 2006, I attended the prestigious Travel Media Showcase, held in Fayetteville, NC. Travel Media Showcase provides a qualified selection of travel journalists the opportunity to meet with domestic and International travel representatives. March 2007 provided another networking and photography opportunity during the Travel South Showcase held in Myrtle Beach, SC.

Now, when I glance at some of my published photographs, I am amazed at how I failed to see the images I captured, while criticizing and doubting my talent. Perhaps I was fearful of admitting I had an 'eye for photography,' and now, I am pursuing digital photography with a passion.

CURRENT POSITION AND RESPONSIBILITIES

After leaving the corporate world, I chose to pursue my dreams, deciding to make the time to enjoy life and work as a freelance photojournalist. How I decided to make this gigantic leap is an interesting discovery. I was tired of working with the Corporate World, tired of schedules, and frustrated that my life no longer belonged to me. I had spent fifteen years of my life trapped inside a company that demanded more than I could give, and when the decision was made to move the company, I recognized a door was closing, but a window of opportunity was about to open for me. After the downsizing, I told my husband it was time for me to do what I love and do best, write and work as a photojournalist.

Friends suggested I needed a degree from a reputable, accredited college to achieve my goals. They also suggested I needed therapy! I smiled, confident within myself, especially since I have a resume filled with publication success and I believe in the power of positive energy. I know my purpose in life and I will accomplish my dreams.

My goal is a profound one. I want to publish photo essays in National publications, not just regional. My friends do not understand why I want the National markets, but it is a simple goal for me. Although the market appears to be highly competitive, I fully believe that perseverance and determination will open the doors I need to open for success. As a teenager, I achieved getting photographs in

national magazines; however, since I was so young, I did not comprehend what an achievement that was at such a young age. Now, older and wiser, I want to reach the goals established and by sending submissions out on a weekly basis, along with preserving clips of all publications with my byline, I am certain I can reach for my star.

My mornings begin early, and I work at my leisure, establishing goals early every January, revising as needed. According to professionals, I am told it takes at least two years or more to open the doors to success. My response is a bold unwavering, I will achieve these goals. Since I have moonlighted previously, I do have a few contacts, although in the publishing industry, editors change positions and companies constantly.

Current projects include photographing various sights I tour for assignments, or freelancing, writing stories about the locations, and querying publishers and other venues. I am targeting restaurant, travel, and hospitality publications. Since I live in a tourist hot spot, Charleston, South Carolina, there are many photographic opportunities. I am working as a volunteer for several non-profit organizations, marketing my professional services as a photographer and photojournalist. I fully believe the more contacts I make, the more successful I will become. My digital cameras, camera bag, and notebook are my constant companion. As a photojournalist, I am always looking for the next photograph, and the next story. My motto is like a cub scout – I strive to do my best and be prepared.

My workday schedules consist of marketing for photographic assignments, and querying publications, including magazine and newspapers. Mostly, according to my experience as a freelancer, I find it difficult to break into publication, especially when queries are returned with comments about the editorial calendar booked until 2008. Some editors express the industry is changing, due to the Internet and the ability of 'hobbyists willing to share images and story ideas, just for the sake of publication.'

My philosophy is nothing ventured, nothing gained. No longer confident in the old school idea of job security, along with corporate politics, I push myself to market my photographs and stories, and when an editor contacts me for assignments, I remind them that I am a professional digital photographer and I can provide all the photographs necessary for the assignment. This usually opens the door for negotiations to begin. In the two years that I have pursued this dream and profession, I have exceeded my own expectations with photography. Submitting a variety of photographs to complement the story assignment, all of the publications have used almost all of the photographs suggested.

RESUMÉ

EMPLOYMENT

June 2005 – Present
CEO Creative Communications Word Prose –
photojournalist, writing consultant, public relations for
hospitality, travel, and media. Photography credits include:
- *Carolina Magazine*
- *Charleston Regional* Business Journal
- *Condition of Limbo,* Memoir, cover photograph of book
- *Construction Equipment Guide*
- *Easy Street Magazine*
- *Hair and Beauty Magazine*
- *Hard Hat News*
- *Johnson & Wales University Alumni Magazine*
- Leighcortpublicity.com
- Onthesnow.com
- SoGoNow.com
- *Southern Hospitality Magazine* – includes cover photograph for magazine February 2007
- *Travel World International Magazine*

April 1988 – June 2005
Johnson & Wales University
During career at Johnson & Wales, served in a variety
of positions, including communications officer where I
photographed special events, student activities and other
activities for the Charleston campus.
Fifteen years experience in the hospitality industry working

in a variety of positions for Johnson & Wales University, Charleston, SC campus

Campus communications coordinator and communications officer at Johnson & Wales University. Performance of a variety of duties including photography, editing instructional manuals, writing press releases, marketing stories about the history of the campus, biographies of chefs, profiles, interviewing Distinguished Visiting Chefs, marketing specialty stories about culinary arts for TV media, newsletters, broadcast, PR tours, and publications.

Publications:

February 2007 cover photograph and three additional photographs, story - *Southern Hospitality Magazine Marketing Strategies for Restaurant Success: Applying the Key Ingredients* - website link: http://southernhospitalitymagazine.com/feature_1_aug_sep_06.html

January 2007, *Celebrations of a Writer,* http://themusemarquee.tripod.com/id185.html

January 2007, The Muse Unleashed, *Querying*

Book proposal for travel guide, tentative title *Legends of the Coastal Carolinas (work-in-progress)*

December 2006 *Southern Hospitality Magazine, WELCOME TO THE TIDES INN Building Chesapeake Traditions and Superb Hospitality,* photographs, and story

September 2006 debut edition Street Throttle Magazine, *Biketoberfest®, Not Just for Harleys,* photographs and story

August/September 2006 edition, Reunions Magazine, *"Vietnam Veterans 9th Infantry Division Reunion"*

July 2006, Live Life Travel, *"Hiking My Dreams at Grotto*

Falls," http://www.livelifetravel.com/griswold/grotto_ falls.html, photographs and story

July 2006 edition, *Hair and Beauty Magazine*, *"Here Comes the Bride: Ways to Soothe Bridal Jitters"*

May 2006 edition, *Hair and Beauty Magazine*, story and photographs, *"Hiking My Dreams"*

April 2006 edition, *Southern Literary Magazine*, *"The Wake Up Call"*

October/November 2005 edition, *Southern Hospitality Magazine, Secrets to a Pleasant Stay*

Healthy Family E-zine, article *Parent to Parent Care Giving in America*, http://hfm9.homestead.com/paretntoparent.html

February 2002 – contract for *Nail Pro Magazine*, national publication

Spring 2002 edition - *Easy Street Magazine* – two feature articles, ten photographs for regional magazine

March 2001 – contributing editor for *Trader News Construction*

A CONDITION OF LIMBO: Chronicles of a Daughter's Unconditional Love, non-fiction memoir, and cover photograph published February 2001

February 2001 – present – reporter, photographer for *Hard Hat News*

November 2000 – June 2001– contributing editor for http://www.Lifetips.com subject elder care. Weekly newsletters, web site

May 2000 – December 2000 - Assignment Editor – Burbage's

August 1998- December 2000 – Reporter, photographer for *Construction Equipment Guide*

PROFESSIONAL MEMBERSHIPS

International Food, Wine, and Travel Writers Association [IFWTWA]

North American Travel Journalists Association [NATJA] member 2004 - 2006

Write Click

South Carolina Writers Workshop, Vice President – 1999-2005, board of directors, membership chairperson

Society of Professional Journalists

www.editorialphoto.com

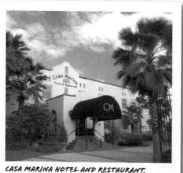

CASA MARINA HOTEL AND RESTAURANT,
JACKSONVILLE BEACH, FL.

Day 1 FEBRUARY 20

PREDICTIONS

- Press trip to Casa Marina Hotel and Restaurant and Jacksonville, Florida
- Meetings with writers, photographers at Casa Marina
- Interviews and tours of Jacksonville, Florida
- Research and development for new projects, photographs

DIARY

Today is a beautiful day to drive to Jacksonville, Florida for the Casa Marina press trip, sponsored by Leigh Cort Publicity. I left Charleston early, arriving in Jacksonville by 1:30. Since the first function is a scheduled tour of the Casa Marina property, penthouse, and cocktails at the Martini Bar at 5:00, I have ample time to take a walk along the beach,

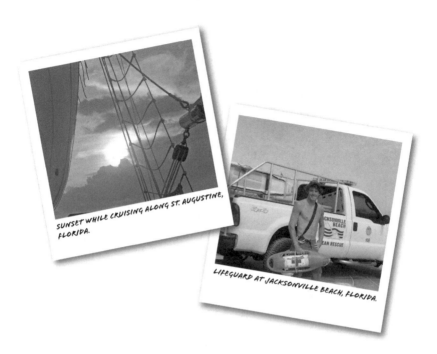

SUNSET WHILE CRUISING ALONG ST. AUGUSTINE, FLORIDA.

LIFEGUARD AT JACKSONVILLE BEACH, FLORIDA.

photograph items of interest, and freshen up.

While strolling along the beach, I discover a bit of compelling scenery, homeless people asleep on the beach. One guy, dressed in raggedy jeans, an oversized T-shirt and a black trench coat, is asleep on a small towel. He is covered with sand, and the T-shirt reveals a chest covered with tattoos. An empty beer bottle rests next to his right hand. I am intrigued by the imagery and get my Canon digital prepared to shoot the image. He hears me, rises, and shouts obscenities at me. Who can blame him? While he breaks the rules, sleeping on the beach, a strange character, a photographer is clicking photographs of him breaking the

law. I reassure him the only law he is breaking is alcohol on the beach. Regretfully, I make certain the images are deleted, but I must say, they were some interesting shots. Continuing my walk along the beach, I photograph images of children frolicking near the shore. One blond haired boy about three years of age, shrieks with delight when the tide tickles his toes. He rushes towards his mother, stopping for a moment to watch seagulls flying nearby.

"Look Mommy," he says, pointing at them. "Beach ducks."

Much to my surprise on this overcast, brisk day in Jacksonville, there is much activity along the shore. A couple of guys play volleyball, older couples walk hand in hand, and children dance along the sandy shore. My camera clicks to photograph the excitement.

My room at the Casa Marina is beautiful, an exquisitely decorated, spacious suite with a queen size bed, a comfortable sitting area, and a striking view of the Atlantic Ocean. Since I am an early bird who enjoys the magnificent sunrises of the Atlantic Ocean, I make a mental note to have my cameras ready for work in the mornings.

At 5:00, the photojournalists meet at the Martini Bar. I'm surprised to note many of the writers I have met before, so the comfort zone is now complete. We make minor chit chat about recent trips, photographs and stories recently published and I confess about a lesson I recently learned.

I submitted a story to one of the publications I write

for on a regular basis. Since I was working on another major deadline, I failed to negotiate payment fees for the photographs. Because the magazine pays on publication date, I did not submit an invoice with the story, awaiting confirmation about the publication date. A few days prior to the Jacksonville trip, I received a copy of the magazine, complete with my story, and much to my surprise, the cover shot on the magazine was credited to me. When I contacted the editor, I was informed that they do not pay for photographs, so I would not receive additional money for the five photographs published, listing me as the photographer. Definitely, a lesson learned, at my expense. After a discussion via e-mail with the publisher and editor, I inform them that future submissions will not include photographs, unless they will negotiate a suitable fee, and I remind them, their magazines are not free so my photographs should not be considered pro bono. After all, I am a professional and expect compensation.

At 5:30, we are given a tour of the Casa Marina, the only privately owned historical hotel in Jacksonville. Built in 1924, the Casa Marina promotes the hotel and restaurant as a family oriented beach hotel filled with opportunities and events for the family. The Casa Marina conducts approximately 3-5 weddings weekly, on an average and they host many business related activities. While we are touring, I notice many historical photographs, all in black and white, hanging on the walls. Pictures of Jacksonville Beach in the 1920s and 1930s, during the heydays as "America's finest beach," additional photographs illustrating the early days

of romance along the beach, and my mind drifts back, imagining what life was like for that historical time of World War II. These compelling photographs leave me spellbound.

Grabbing my Nikon D-50 digital, I shoot several photographs of the interior of the Casa Marina, designed with Spanish Mediterranean architecture, an oceanfront verandah, spacious dining room with cypress ceilings, and the flowing white sheer window treatments. The stair railing is the original woodwork. When the hotel was built, it contained 60 rooms, newly remodeled, Casa Marina has 23 rooms and a penthouse. The hotel has an interior sprinkler system, tiled roof, and beautiful wood floorings. This is a beautiful, romantic venue to have a destination wedding. Ideas I have for photojournalism opportunities include:

- Casa Marina – where you can have the wedding of your dreams!
- TENTO CHURRASCARIA RESTAURANT: Tentos Introduces Americans to the Brazilian Flair and Romance of Fine Dining
- Jacksonville Beach – Gateway to It All!
- What are Run Outs and Why Should a Beach Bum Care?

Dinner for our group is at Tento Churrascaria Restaurant, a Brazilian theme restaurant with mouth-watering food that melts in the mouth. Before taking a bite, I photograph several images of the plated food, along with the ambience of the restaurant. Brightly decorated with several complimentary shades of coral, the mood at Tento's is set

for romance. Anyone who has ever photographed food recognizes how difficult the textures, colors and appeal of food can be, and at times, I wonder, is it best to cut into the juices, or leave the plated food alone. I've heard many discussions about the correct procedure, deciding that food is in the eyes and temptations of the beholder. After a long day, I return to the Casa Marina, to view my images in the Canon and Nikon digital cameras.

LESSONS/PROBLEMS

An interesting day with many compelling discussions with other writers and photojournalists. One interesting lesson I have learned today is the fact that working as a freelance photographer and photojournalist is a profession where one cannot be shy. If permitted, there is the potential for the photographer and writer to be taken advantage of, especially where the term *freelance* is concerned. My reluctance, or absent-mindedness when submitting the digital images to the publisher a few weeks ago resulted in no compensation for the photographs. While I am proud to say one of the images made the cover of the magazine, the lesson I learned for this assignment is a simple one – negotiation is the key. Photographers, like writers, should not allow themselves to be taken advantage of - EVER. When I speak to others, sharing words of wisdom about life as a professional photographer, I will stress the importance of negotiating the terms prior to submission – ALWAYS. Negotiation is the key!

Day 2 *FEBRUARY 21*

PREDICTIONS
- *Meeting with Julie Depew, Casa Marina Sales Director*
- *Touring the Beaches Museum and History Center*
- *Visit the American Red Cross Lifeguard Saving Station, Jacksonville Beach*
- *Evening – Dinner in the Grand Salon Dining Room with Executive Chef Aaron Webb*

DIARY

Morning starts early here at the Casa Marina. From my window, I have a gorgeous view of the Atlantic Ocean and cannot resist photographing the morning sunrise. Since I am photographing from my window, I stand at about a 45° angle, making certain not to use a flash, and I shoot.

The more I use a digital camera, the better I like them. Although it is a bit difficult to see the image within the viewfinder, I am able to glance at the imagery and shoot additional shots, if needed. A good rule I use is to shoot at least two shots of images I plan to use. Clicking quickly with my Nikon D50, I shoot a few more, deleting two of them, saving the rest.

After a breakfast meeting, the group of writers and photographers meet in the lobby. We follow in a convoy, headed to our first location, the Beaches Museum and History Center. Holly Beasley and Lisa Paulger share an overview of the history of Jacksonville Beach. Back in the

1920s and 1930s, Jacksonville Beach was a hopping and aristocratic place to schmooze with the rich. Considered a hot spot for filming, Jacksonville Beach shared fame with John D. Rockefeller, President Harry S. Truman, and Jean Harlow and Al Capone were rumored to love the area, visiting on a regular basis.

Today, we have a full schedule of events to do, including a tour at the American Red Cross Lifeguard Saving Station, Jacksonville Beach. Requirements to become a beach patrol include an extensive 12-week training program and all team players must be members of the American Red Cross. The philosophy for the team is to always apply the rule, "When in doubt, Go!"

Touring the American Red Cross Lifeguard Station, I take several photographs of the building, exhibits, including the beach wheelchair, team members, equipment, and one of a young rescue squad member standing beside the truck, ready for action. Before I could get his name, he was called into action on the beach.

With a few minutes to spare, I stroll along the beach, taking photographs of the beach, buildings, architecture, and the Pablo Train Station. After lunch at Joe's Crab Shack, we have the afternoon free to explore the beauty, charm, shopping, attractions, and all that make Jacksonville Beach such a beautiful city to photograph.

With the afternoon free, I drive back to the hotel, park the car, and gear up with camera bag and two digital cameras.

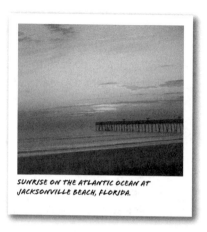
SUNRISE ON THE ATLANTIC OCEAN AT JACKSONVILLE BEACH, FLORIDA.

Wandering around the boardwalk, I notice a few historical signs including Doolittle's 1922 Record Flight, and several attractive signs posting the rules and regulations of the beach. No loitering. Dogs must be leashed. No alcoholic beverages allowed on the beach – the usual beach rules. I head towards the boardwalk, discovering an entrance gate. Not wanting to pay a fee, just to walk a bit on the boardwalk, I apply a tip I've used many times when photographing when a chain link fence is in the way. Slipping the camera lens on the chain link of the fence, I shoot several shots, making certain the chain link fence is not in view. Later I will check to make certain these are good shots.

Strolling along the beach, I photograph shots of Jacksonville Beach. On an overcast day, this scenery makes for good imagery. I capture shots of people sleeping on the beach,

playing volleyball and children rushing towards the ocean. I am captivated by a small toddler who is mesmerized by the water. Carefully he rushes toward the water, his grandmother rushing behind him, laughing at him as he tumbles onto the shore. I stop her for a moment, asking if I can take a few photographs of him at play. I give her my business card, telling her I will send a few photographs her way if she has an e-mail address.

"What's e-mail?" She asks. "Is that one of those new technologies that I am still stuck in the dark ages about?"

I nod. She tells me to take all the photographs I want.

"Isn't he just darlin'?"

No doubt, those photographs will be 'priceless!'

I continue shooting photographs of this precious child laughing and frolicking along the Atlantic Ocean. Like the lens of my camera, this child is discovering the little things in life that are so important to everyone!

LESSONS/PROBLEMS
Since this is a press trip where I have my own personal transportation, it is easier for me to have the necessary time to do what is needed while on location, without inconveniencing anyone. My rule while traveling is a personal one – if the location is less than ten hours away, I drive; otherwise, I will consider flying, leaving me a bit limited with transportation needs. Today has been a great

day for photography. Not many clouds in the skyline and a bit overcast; however, most of the photographs I took are of the quality I require.

As a photographer, I like to test the natural 'golden hour of light,' usually in the mid afternoon when the light is natural, bright, and beautiful, providing a kaleidoscope of vibrant colors. Morning sunrise light is good; however, the brilliance of the rays of natural light during the 'golden hour' is spectacular and I cherish taking photographs at that time.

PREDICTIONS
- *Contact PR offices to arrange visit for photo session*
- *Review information for photo shoot – Magnolia Gardens*

DIARY

This morning started early, refreshing my memory and reviewing information from the press trip, transcribing notes, and arranging time to research Magnolia Gardens. A current assignment under consideration is a story about the gardens of Charleston, along with destination wedding sites. Since Charleston is a city popular as a destination wedding vista, I see much potential in the location of Magnolia Gardens. Reviewing the web site, I am convinced it is the perfect location to shoot, so I contact the PR office.

The PR office at Magnolia Gardens responded within minutes of my correspondence (a most unusual response, I might add) stating I could come by at my leisure, as long as they know the date, so after confirming it is OK to visit today, off I go, making certain prior to loading up that my camera battery is charged, tripod packed, and extra memory cards in place along with a tape recorder.

Magnolia Gardens is located on Ashley River Road in Charleston. Considered as one of the *Must See* tourist destinations in Charleston, the acres of breathtaking land, the plantation, gardens, the long bridge, sweeping oak trees

covered with Spanish moss, all are a photographer's dream location.

Arriving at Magnolia Gardens, I decide not to take a tour since I am squeezed for time, and I want to explore the art of photography at the gardens. Since it is February, the gardens are not officially in bloom. I am convinced that springtime arrives first at Magnolia Plantation and Gardens, especially when the azaleas awaken with the beauty of springtime in the South. Depending on how the climate is in Charleston during the winter, an early spring is knocking on the doors of Magnolia Gardens. With the early blooming of the azaleas and daffodils, the magnolia trees, and flowers and magnificent landscapes, are breathtaking. If asked to describe my favorite place, or thing to do in Charleston, I would have to say it is to visit Magnolia Gardens. Every visit will reveal a kaleidoscope of colors, shapes, images, patterns that appear to make photography so easy. However, when photographing nature, such as butterflies, alligators, birds, especially the beautiful egrets, blue herons, and all that is so prevalent at Magnolia Gardens, it is so hard to grasp what is my favorite. I enjoy taking photographs of the long bridge, the flowers, and nature. Nature photography is truly one of my favorites! Today, I have both of my cameras available and within reach (the Canon and Nikon D50 digitals) and I am thankful I am using digital photography. I would spend a fortune in processing fees if I used my Canon 35mm. Today, the lighting appears almost perfect, a gray, overcast day, providing easy light without shadows or glare.

Strolling along the magnificent gardens, I must say, Magnolia Plantation and Gardens is truly the place for a destination wedding. Although I do not see any indications of weddings while walking along the gardens, I remind myself today is Friday and most weddings in Charleston are held on Saturday. The Carriage House location would be a nice spot to host a destination wedding and it overlooks the river. If I planned a wedding here, I would desire a garden wedding by the long bridge. This is a romantic and beautiful place to host an intimate wedding. Every season at Magnolia Gardens provides different venues to enjoy. In springtime the grounds are covered in a patch work quilt of colors, flowers, and floral scents. Summer is a bit humid here in the South, so I am hesitant to visit, unless I have an assignment, due to the extreme heat. However, during the summer, alligators, egrets and all sights, sounds and forms of nature are within reach. The camellias decorate the gardens in November and are quite popular among the locals. Now, I recognize there are many beautiful settings in Charleston for the subject of destination weddings.

Three hours later, I arrive at home, excited to review the images from both cameras. I download 75 images from the Nikon D50, and 120 from the Canon Rebel. My favorite shots are of the long bridge. There is something magical and romantic about the imagery contained and I am pleased with all the photographs.

LESSONS/PROBLEMS

Many people are under the impression that a perfect day to

take photographs is a bright, sunshiny day. Speaking only from my experience, a selection of my best shots have been on an overcast day. If I had to explain why, I would say, on a bright sunshiny day, there are many shadows, and colors that simply are too brilliant, resulting in photographs that are not of the quality I desire. I have noticed my best shots are generally on an overcast day, providing a natural light that compliments the imagery. The lighting appears softer, and shadows or glare are not a problem.

On a recent location shoot, I attempted a silhouette image of a statue of a woman and deer. It was early morning with the sun beaming on the subjects, so I chose to stand in the shade, letting the sunshine serve as a backdrop to the subjects. When I reviewed this image later, I discovered an important tip I shall practice again. Standing in the shadows of trees, with my face to the sun, the subject had a backdrop of the sunshine, resulting in an interesting silhouette.

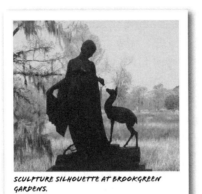

SCULPTURE SILHOUETTE AT BROOKGREEN GARDENS.

Day 4 FEBRUARY 26

PREDICTIONS

- *Today will be a test of stress levels, organizational and coping skills simply because my home office is scheduled for a renovation in the kitchen area. Organize photographs*
- *Send queries to publishers, magazines*
- *Take photographs of the remodeling project*

DIARY

Due to the mass confusion I will have this week, I am thankful I took the weekend off. Our kitchen renovation starts next week; therefore, I must get a grip and organize everything for this significant interruption in my daily work routine. The morning starts like most, with e-mails to respond to, queries to write, packages to mail, and I must

make time to take additional photographs of the kitchen disarray. I research markets, using Wooden Horse Magazine Database, Power Pen, and Writersmarket.com. Although these are mostly resources for writers, there are numerous sites listed for photojournalists, and many of the guidelines list photography guidelines too. My preference to use is Wooden Horse since it is updated almost daily and I have accomplished several assignments from the database.

Due to the disorder of the work place, I will spend the workday researching and revising the business aspects of photojournalism. While it is true that most of my friends are envious of my life as a writer and photographer, I doubt they understand how much research time I consume searching for markets, sending queries, reviewing my goals and following up with the business of writing.

For 2008, my business goals state the following:
- Increase income from writing and photography by targeting corporate markets, including advertising firms, copywriting/marketing assignments and other resources
- Increase publication credits by sending queries out on a regular basis.
- Publish at least one story, photograph weekly
- Sell and resell photographs and stories

On an average, I am submitting five to ten query letters to various publications on a weekly basis. Since most of my photographs are digital, and target film, hospitality, food and nature settings, I target those markets. I strongly

encourage anyone who wants to be a professional photographer to write goals every year. Be prepared to adjust, revise, and rewrite them.

Phil came home from work early today and he can see from my face that I am frazzled, with all the mess in the kitchen. He suggests a boat ride for the afternoon. Seizing a photographic opportunity on the water, I grab my camera bag and off we go. The harbor waters are like a mirror today, smooth and relaxing. We head out towards the new bridge and I am in heaven while shooting a number of shots of the beautiful Arthur Ravenel, Jr. Bridge.

Cruising along the harbor, we stop by Patriots Point and I take several shots of the Carolina Belle and the USS Yorktown. The sun is setting and the colors are stunning. Leaving Patriots Point, we notice dolphins. With my camera ready, I struggle to capture the moment as they surface. Now that I am a photographer, I have a new respect for nature photographers who capture the perfect shot of dolphins swimming along the ocean. If there is a secret to dolphin photography I do not know it, and suspect it is probably best achieved underwater. Nevertheless, I managed to take several close shots of my favorite bird, the egret, both in flight and while searching for prey. I zoomed in tight, managing to get a nice profile shot with his reflection in the water, and during flight, his wings outstretched. I plan to frame them and market these shots to nature magazines.

LESSONS/PROBLEMS
The days of remodeling have not been productive and

I realize there is something to be said about working outside of the home, instead of having my office at home. Interruptions of daily household life, especially during remodeling, seem to get in the way. Weighing the *Pro and Cons* of my life as a freelance photojournalist is quickly forcing me to change my business cards and remove *freelance*. Friends, acquaintances, neighbors, and of course, family, have the tendency to believe that because I work out of the home, and I schedule photo shoots and write at my leisure, I can always stop what I am doing and accommodate them. If only they could see me when the deadlines are approaching and I am pushed to get things accomplished. The numerous nights of lack of sleep and burning the midnight oil, just to meet a deadline take a toll on me. Only a writer and photographer can understand how frustrating it is when family considers what we do is just a hobby, or something we can always do later on. Perhaps those without an eye for photography or a passion for words fail to understand events of daily business life. Photography, like writing, is an art form, and at times, an artist needs the muse of inspiration, without interruptions, just to complete the task.

The photographer tells a story through images. A writer tells the story through words, characters, emotions, and imagery, much similar to a photographer. Working as a photojournalist, I use both mediums, so my focus must be in tune, just like a musician, dancer, or actress. Focus! A photographer focuses the camera and the subject. A writer focuses the words and subjects, and at times, it is

an impossible undertaking, especially when interruptions intercept the thought and motivational process.

Perhaps I need to practice the philosophy of Nancy Reagan and "Just say no."

PREDICTIONS

- *Research*
- *Write query letters*
- *Back up files*

DIARY

Remodeling is quickly becoming a four-letter word for me since someone must be home during the process. The day starts like most, until the contractor arrives and the noise of hammers, drills, saws, personalities, and unexpected surprises occur. I sit at my desk, organizing my Things to Do list. While the sounds of screeching drills echo in my ears, I realize this is the week to back up files, research and attempt to let the creativity of the images photographed tell a photo essay.

As stated previously, I subscribe to a variety of market resources, including *Worldwide Freelance Writer*, Freelancewriting.com, Writersmarket.com, and several others. Most of these resources provide writing and photography guidelines. I read the editorial calendars, and writers and photography guidelines carefully, and research the publication with a critical eye, both online and at bookstores. Glancing through magazines, I pay attention to the advertising, the table of contents, and stories and photographs published. Researching for the proper markets is a tedious task, but the guidelines of the publication must

NATURE MAKES FOR INTERESTING SHOTS,
ESPECIALLY WHEN A BUTTERFLY COOPERATES.

be followed. Most publications will provide the writer and photography guidelines, on either the web site, or a personal request in writing.

My query letters as a photojournalist contain three or four paragraphs, starting with the idea I am proposing. Briefly, I list my credentials, and why I am a good candidate to write the story. I confess, I dread writing query letters, but writers and photographers are constantly marketing their services. Some publications prefer a CD, while others prefer Slides. Most of the publications I work with prefer digital photographs, saved in a PDF file, on a disc. On rare occasions when I use my Canon 35mm camera, when processing I always request a CD so I can use the photographs later. Always check to make certain the guidelines are followed.

THE ROLLING, TRANQUIL HILLS, AND VALLEYS
OF KENTUCKY AT SNUG HOLLOW.

When I am on assignment as a photojournalist, I write the story, build a box where the photograph is suggested, write a caption, and add a Contact Sheet of the selected photographs separately in the package. Normally, I provide the publication with a total of twenty photographs. I have been fortunate and many of the photographs have been published with the story, but the selection of published photographs is always the decision of the editor.

Years ago, when I started building the foundation to a career as a photojournalist, I filed all of my queries in a file I titled Correspondence. Now, with over 100+ queries in the submission stage, I do not practice that philosophy. I create a submission tracker report, formatted as a table in Microsoft Word. Copies of every query sent are placed in a 3" three ring binder, filed alphabetically, according to the publication name. My submission tracking report is updated on a weekly

basis. My report is a simple one, formatted in the landscape orientation of Microsoft Word. There are query tracking software programs available; however, I have not located one suitable to meet my needs, so I formatted a simple, easy report that works for me. Another organization tool I use is to make a file for every query submitted, according to the subject matter. For example, if I am submitting a photo essay about Vietnam Veterans, I place copies of all of the queries submitted in a file titled Vietnam Veteran queries. Now that I am pursuing this as a full-time career, I need to have access to the files within a moment's notice. By practicing this, it allows me to pull the file and refer to all correspondence, without fidgeting and searching for the reference materials. I have a separate filing system for all of my digital photography and file them according to the queries and subjects.

LESSONS/PROBLEMS

Getting assignments as a photographer or photojournalist does take time. Many publications will take three to four months, just to respond to your query. One of my recent assignments took me over three years, and much follow up. The original letter was mailed, never receiving a reply. The next letter was transmitted electronically through e-mail. I waited three months for a reply, and then I submitted another letter. A few weeks ago, that letter generated interest from the editor of the publication and she phoned me, giving me the assignment. Since my letter indicated I did photography, she inquired if I still had images available. When I replied that my digital photography complimented

the story, she sent a contract to me, including photography guidelines. Working as a photojournalist, it is crucial that you keep updated records and follow-up in a timely fashion. Although it took me three years to get this assignment, the end result is another publishing and photography credit added to my resume and portfolio, and the story will be available for readers to enjoy.

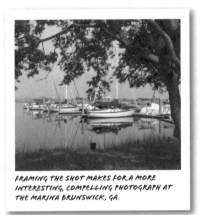

FRAMING THE SHOT MAKES FOR A MORE INTERESTING, COMPELLING PHOTOGRAPH AT THE MARINA BRUNSWICK, GA.

Day 6 FEBRUARY 28

PREDICTIONS

- *Complete a photo shoot at Patriots Point*
- *Downloading images – Picasa and Adobe Photoshop*

DIARY

The demolition of the kitchen is almost done. Today is the first day I actually have a bit of freedom to work on photography, and with such disarray in my home, I feel the need to get outside and work.

When my interest in photography returned a few years ago, I was hesitant to purchase a digital camera, and until I was on a trip with a bunch of other photographers, I was skeptical. After all, I had a Canon 35 mm camera, with a

collection of lens and filters and I was happy with the images I produced. I suppose I was a bit close-minded because I was not aware of the convenience of digital photography and I was most concerned about the resolutions and professional quality. I wanted my photographs to be clear, sharp, and stunning, suitable for framing and publishing. After observing a travel photographer using a Canon digital on a trip, I was convinced it was time to open my mind and learn more about digital photography. The images he showed me on his viewfinder convinced me that digital photography was not a 'wave of the future,' it was reality.

Now that I am working full-time as a photojournalist, I appreciate the knowledge and forewarning he expressed. I am thrilled to have three digital cameras now, including a recently retired Panasonic Lumix, my first digital camera. Although the Lumix took a good photograph, I was not happy with the sharpness of the images and the camera lens could not be removed; therefore, I was stuck using the lens attached. I cannot express how many times I missed the perfect shot of a blue heron, or woodpecker flying by, and forget shooting butterflies on flowers. Dolphin photographs I shot with it were only a stream of glare and shimmery – a word I use when expressing how displeased I am with some of the images of this camera. Using the Panasonic, only once did I achieve a suitable shot of moving objects. My husband and I were cruising along Shem Creek in Mt. Pleasant, enjoying a beautiful spring day on our pontoon boat. I was playing with the camera, shooting images of the trawlers and pelicans, hoping to get a good shot of the pelicans.

When I got home, I downloaded the images, discovering a great shot of a shrimp boat and a pelican gliding across the water in the foreground. I was pleased with this photograph, and gave a few copies of it to special friends for Christmas. I still have possession of this camera, and might use it again – when the time permits. Maybe!

For Christmas, Phil gave me a Canon EOS Rebel digital camera. Since I have a Canon 35 mm, I was able to interchange the camera lens from both cameras to use on my digital. I have the following lens to use on my Canon digital:

- EFS 18-55 mm
- 70-300 mm
- 80-200 mm

I have been completely satisfied with the Canon and use it most of the time. Additional items I purchased are an extra battery, and several memory cards. Since I take an abundance of photographs when on assignment, or just for fun, I want to make certain I have enough memory cards on hand.

Recently, Phil gave me a Nikon D50 Digital. I have two (18-50 mm and 55-200 mm) digital lenses I use for the Nikon. Unfortunately, the Nikon and Canon lens do not interchange, so as you can see, I have a bit of change invested in photography equipment. If asked which of the cameras I prefer using, my response is a simple, "It depends." Both the Nikon D50 and Canon Rebel shoot incredible photographs and I enjoy using them. Both

cameras capture moving items without leaving a foggy image or streak. No shimmery! I have had much success using both cameras when shooting aquariums, while riding in the car, and photographing fast moving items such as birds.

Presently, I am in the process of learning more about photography software products, including Adobe Photoshop and Picasa. I downloaded the free copy of Picasa and use it frequently to review photographs. Adobe Photoshop appears to be user friendly, but it has many features I am not familiar with and will need to play with it more often to learn more about this amazing bit of technology. I am adding *Learning Photoshop* to my goals for this year so I can become well versed with this program. Most of the editors I target appear to prefer digital photographs submitted as JPG files and Adobe Photoshop has this capability.

With the construction crew gone, I now have time to drive to Patriots Point to take the photographs. It is mid-afternoon when I arrive and the lighting, skies, and subject matters of the USS Yorktown, tourists boats, and the view of the Charleston harbor are perfect.

Today's photo shoot was scheduled so I could have additional stock photography available for story ideas I am pitching to several local and regional magazines. As a photojournalist, I find it easier to query story ideas by mentioning I have digital images available for the publisher. Most editors appreciate that I have the images available and they will not have to hire a professional photographer, since

I have images. When I am querying magazines, I always refer to my web site so the editor can review several of my images. I suppose I've been lucky in that respect, since the magazines I have worked for have always liked my clips.

Because the lighting is so terrific today, I shoot several angles at Patriots Point, using my Canon Rebel digital. One special shot on the viewfinder reveals a great shot of the cannons by the Yorktown. I move to another angle, standing to the right of one cannon while a seagull flies nearby. The image is a great one.

Arriving at home, I download 75 images, all of the harbor of Charleston, Patriots Point, the USS Yorktown, and of course, the Arthur Ravenel, Jr. Bridge. I am certain I can use many of these images to markets, especially regional publications located in South Carolina, Coastal Carolinas, newspaper and magazines.

LESSONS/PROBLEMS

To recap the problems of this date, I have to say the remodeling project for the house is definitely placing a constraint on my ability to photograph. Another problem is my lack of knowledge with Adobe Photoshop.

Speaking with other photojournalists, I am encouraged to take the time to learn the program, and I will place this task on my Things to Do list; however, due to deadlines, I am always squeezed to the limit with time constraints, even though I work almost every day. Another task is the research

for markets, reading the guidelines, and writing the query letters.

Reading and following the guidelines is a tedious task, but it is crucial. Many of the guidelines require you to submit via snail mail (U. S. Mail, complete with a SASE [Self Addressed, Stamped Envelope]. Other guidelines will state to contact them only via e-mail. Practicing the rules of submission is the wearisome portion of marketing that every writer and photographer I know detest, but it must be followed!

Other photojournalists and I have shared advice about querying – whether to query via e-mail, or snail mail. My advice to all of them is a simple, *read the guidelines and follow them.* While it might be easier to e-mail instead of mailing via the instructions from the guidelines, I want my reputation to speak for itself, stating that I am a professional who strives to make an impression. Of course, it is true that rules are made to be broken; nevertheless, I want my photographs and stories to be published, not deleted via the click of a button.

My weekly goal of submitting five query letters weekly is right on schedule, but it is a tedious chore. Writing and photography colleagues tell me that with time it will get easier for me, especially when I tap into the higher paying markets and when the discovery of my talents as a photographer and writer are achieved. I remind myself of the old cliché I have heard all of my life, *"Good things come to those who wait…"*

PREDICTIONS

- *Prepare photographs of Philip Simmons, world-renowned blacksmith story*
- *Organize Kentucky images*
- *Research five markets for query letters*

DIARY

Today is a day of research and marketing opportunities. Reviewing my query submission report, I have five queries to submit, including stories and digital photographs about *Mobile, AL – A Cultural City Where History Is Preserved, Safety Tips While Walking Your Dogs, Teaching Children The Fun Of Cooking, The Fabulous Palm Springs Follies and Welcome to Oak Ridge, Tennessee, A City of Secrets and the Manhattan Project.* Many of these queries include the fact that digital photographs are available, along with a request to send photography guidelines, if I could not locate these guidelines either in a publication, or on the Internet.

Although many publications do not recommend simultaneous submissions, the majority of photojournalists I know will admit to the fact that they practice a query letter campaign to several publications at the same time. Because of the length of time it takes to hear from a magazine, [sometimes three months, or much longer] I admit I have practiced submitting multiple queries; and when the day arrives that I get two or three assignments pertaining to the

same query letter, I will consider all of my options. Among the considerations for acceptance are the following:

- Is the magazine or newspaper a POA (Pay on Acceptance) or a POP (Pay on Publication Date) publication.
- What is the pay rate?
- Photography rate – I have discovered a few do not pay for photographs, although they may want all rights for the photographs. I encourage anyone who wants to pursue photography as a profession [and not a hobby] to negotiate the fees upfront! Many publications do not pay for photographs!

Never do I release all rights to anyone. The photographs and the stories are my copyright and as a professional, it is my responsibility to negotiate the terms of the contract. Before I accept the assignment, I make a list of all benefits such as the distribution and circulation, quality of the publication, rate of pay, is a contract provided, and other professional considerations.

Today I spent a bit of time organizing the photographs I took while in Kentucky. Building a stock list, I organized images of an Amish coach, coal mining, making an additional file of images pertaining to the coal mining areas of Butcher Hollow, and Van Lear, Folk Art, My Old Kentucky Home, Pottery, Restaurants, Food, Accommodations in Kentucky, and about five additional files. By building a stock list file system, it will be easier for me to track and find the images when assignments roll in – and I'm certain the assignments will be knocking upon my door soon! I keep

telling myself, *Good things come to those who wait, and I am waiting!*

The pictures I took of Philip Simmons, the world-renowned blacksmith, and a Native of Charleston, are almost timeless because the images contain so much of his personality. He was truly a super subject matter to interview and photograph, especially when I took a close up shot of his face and his magnificent eyes filled with such character. His beautiful blacksmith artwork added to the story and the photographs. His photograph is framed and hanging on a wall in my home, all because I captured his passion. Today, I prepared an updated query letter, mentioning I have photographs of the artist and his work. Mr. Simmons is truly a subject matter that all photographers dream about capturing; the passion in his eyes, and the modesty on his face, said so much about him. His photographs tell the story about him and his artwork, without adding words.

Time seems to fly when you lose yourself in your work and today has been one of those days where time slipped away. I was so involved with research, writing queries, and organizing photographs in a stock file listing that before I realized it the clock was ticking and it was 3:30. I usually take a break, but when you work from home, time slips away. At least today was a productive day where I was able to keep the focus of the projects at hand organized and I reached my goal of accomplishment.

LESSONS/PROBLEMS
Checking the mail, I am hopeful I will hear from some of

the queries outstanding. Unfortunately, today is not a day for such correspondence, so I return to the dreadful task of sending queries, updating all records and reviewing my digital photographs, including the photographs of Philip Simmons, and my trip to Kentucky. I am having a bit of difficulty deciding what images to include with the Kentucky story, so I will send an e-mail to the editor next week. I have placed this on my Things to Do reminder form.

Don't be timid when photographing. Shoot. Click. Shoot. Click, and shoot, click again! If using a digital camera, make certain you have enough memory cards on hand to take an abundance of photographs. Nothing is more frustrating than to have the camera flash, *Memory Card Full* and not have additional cards to use.

Be certain to keep a variety of batteries in your camera bag and check them often to make certain they are charged and ready to work. Also, when using a flash attachment, make certain the batteries are in good working condition.

CHOCOLATE SCULPTURE OF ART, ALMOST TOO STUNNING TO EAT.

Day 8 MARCH 2

PREDICTIONS

- *Charleston Food and Wine Festival this weekend*
- *Festival Media Luncheon at Charleston Place*
- *Organize e-mail, clean out Inbox*

DIARY

Charleston Food and Wine Festival is scheduled for March 1–March 4. In early February, I submitted my writing/photojournalism credentials to the media link, requesting a VIP pass, and will attend the luncheon today at noon, along with other events. According to an e-mail from the media office of the festival, I was selected to attend the luncheon and one additional event. My schedule will dictate the other event since I need to make certain nothing else interferes.

Today, I will carry my Canon Digital camera and take photographs of Charleston Grill and the downtown area. Fortunately, the staff at Charleston Place knows me since I have published two stories about the restaurant. Due to the limitations of parking around the downtown area, I will park the car at Charleston Place and walk around downtown.

The luncheon at Charleston Grill was delicious, and the media in attendance sampled shrimp and wine, and heard a discussion about the shrimp industry, sustainable seafood, and the events happening this weekend.

Working with the Convention & Visitor's Bureau (CVB) I get invited to many food and travel tourism related events, since I am a writer and photographer. I know several of the people who work at the CVB and they know me, based on the published stories with photographs I send to them after the publication hits the newsstands. It is my practice to send copies of the magazine stories to the parties the story is about, and to the local CVB. By making this a part of my business procedure, it keeps my name fresh to them, and they remember that I always keep them informed about published clips. I make copies of the front cover of the magazine, the masthead (listing all credits and editors) along with a copy of all stories written by me that are in the magazine.

Most of the events at the Charleston Food and Wine Festival are 'comped' to writers, and other related media who are listed on the approved/credentialed list, and we are treated like VIP's (very important people) probably

because the workers, crews, and special event gurus recognize us as media and will go above and beyond to see that we are treated well. Normally, we wear a nametag that distinguishes us as media, so I am certain when they see the name tag, they know we are noticing all actions, food preparations, styles, and service. The downside is the chefs, and speakers, are so busy they do not have the time to mingle with us and answer our questions. My practice is to submit a questionnaire to the PR professionals responsible for the event. I can almost guarantee I will need to follow up within two weeks to remind them I need the questionnaire faxed or e-mailed. During the event, I stay in the background, capturing candid photographs. After the event, I start a query submission campaign, targeting food, hospitality and regional magazines.

Today, I managed to take several photographs of the entrees presented and most were pleasing to the eye. Food photography is difficult, especially to get the right color, texture, and freshness of the food. I suppose the question to ask is – What makes food photography so difficult?

Have you ever photographed a simple bowl of cereal? Trust me, it is difficult simply because when the milk is placed in the bowl, the cereal usually becomes a soft and limp consistency of mush. A food stylist photographer who served as a mentor to me mentioned there are many tricks used in food photography, including the use of white glue on cereal. I have not tried it, but I do know some of the tricks my colleagues have used, including painting a turkey with kitchen browning sauces, and on one shoot, a photographer

ON A BRISK DAY IN CHARLESTON, TOURISTS
ENJOY THE VIEW AT FT. SUMTER.

stated she used a can of spray paint to make a turkey look browner. I have not used any of these techniques so I cannot recommend any of them.

Most of my food photographs are taken during visits to restaurants when on assignment, or whenever I am invited to fine dining establishments. I must say, that is one of the benefits of working as a professional photojournalist – I get invited to restaurants, and I am invited to visit cities and events I never anticipated. For example, the Food and Wine Festival is a popular event in Charleston, and many people pay a lot of money for the tickets. Working in the media, I am invited, and able to attend as a VIP. It took me over two years to establish myself as a writer, and not a hobbyist, in the Charleston area. Perhaps much of that is because I have a limited amount of "local" stories, but now that I am on the proper media list, I receive updated information

and a Calendar of Events from the CVB on a regular basis. Reviewing these e-zines (usually delivered to your e-mail address) keeps me informed about local, regional and national events. One of the best resources a photographer can use is a great relationship with the Convention & Visitors Bureau, Chamber of Commerce, Tourism and Recreation Departments and other resources who can add the photographer and photojournalist to their media listings.

LESSONS/PROBLEMS

Walking with a camera in the downtown area is always a challenge since the sidewalks along the Market, East Bay Street, and Broad Street are not in compliance with the American Disabilities Act. The sidewalks are not smooth, due to roots, lack of repairs, flooding and high tides either washing them away, leaving them uneven, and dangerous, especially if walking with high heels. When I am dressed in business clothing and carrying camera equipment, I find myself focusing on the sidewalks, instead of events happening around me. Today is no exception.

In 2005 when I worked downtown, I wrote a letter to the Mayor's Office about the unsafe sidewalks, after falling and bruising my knees. Amazingly, within two weeks, the sidewalk I mentioned in the letter was repaired. Last year when I approached the public information office, they were not too pleased about my questions, but as a photojournalist, I will tell the truth, not sugarcoat anything. I was most diplomatic, but a writer and photographer must do the best to inform the public, without negativity. I

suppose it did help to mention I had taken photographs of the sidewalks and was concerned, since Charleston is a city filled with tourists.

After a busy day, I decide to organize e-mail later.

DINING AT CHARLESTON PLACE HOTEL AT THE CHARLESTON GRILL.

Day 9 *MARCH 6*

PREDICTIONS

- *Organize e-mail*
- *Transcribe notes from Food and Wine Festival*
- *Organize photographs of festival*

DIARY

The Food and Wine Festival was quite successful, another impressive culinary event for a city now world renowned for fine dining and gourmet cuisine. Although this is only the second year for this annual event, it was publicized well by locals and celebrities. One event I failed to attend, due to the remodeling demands of my house, was the Charleston Cooks! Culinary Village. There was a celebration of gospel music, brunches, dinners, barbecue, restaurant

dine-arounds, and cooking demonstrations. Since I was not selected for so many of the events, I am certain I will have another chance next year. My credentials are increasing, especially in the hospitality, restaurant industry and in the travel genre. Fortunately, the kitchen renovation will be completed soon, and my life will get back to a normal schedule. Sometimes, with all the hassles of life, it is hard to focus.

I plan to spend the hours of this date organizing digital photographs, compiling more stock lists. I have files placed in Picasa and Adobe Photoshop. Although I have a general idea about the files, all recorded with the subject matter, since I plan to start research for a new goal established this year – a goal of placing some of these photographs with stock agencies, it has occurred to me that organizing these files must be performed. I will systematically file all the images according to the actions or subjects. For example, the shots I took of the jazz band at Charleston Place Hotel are filed under Charleston Place Hotel. Since I plan to target images with stock agencies, I need to move some of these images into a new file titled musicians, or other subject matters. This will be an ongoing process, demanding much time, so I will consider it another aspect of research. This is another tedious task of the business of photojournalism and photography.

While in attendance at the Charleston Food and Wine Festival, I was able to see Tyler Florence of the Food Network. I confess, Tyler and I met when I worked at Johnson & Wales University. Now that he is so successful,

EXCELLENT IMAGERY FOR A STORY ABOUT LONELINESS, INSPIRATION.

and recognizable, it is a bit difficult to get to speak with him personally, but he nodded my way and said hello. No, I did not get to photograph him. His public relations assistant was rushing him around. I suppose seeing Tyler was the highlight of the festival for me. The crowds bothered me a bit since it was congested.

I jotted notes down while photographing, deciding it might be easier to record my observations in a tape recorder. Working the event, I photographed a variety of foods, especially the desserts, and I shot a bunch of action images of people at the festival. Most of the photographs are from a distance, so the people are not identifiable, and captions were not necessary. I can add captions to the images when submitted for publication. To say it was a bit hectic is an understatement, but a photojournalist adjusts and goes with the flow. Highlighting so many of the talented chefs in the

PONDERING HIS THOUGHTS, OR COUNTING FISH?

Charleston community, the festival was successful and it was an experience I will be able to write about targeting travel, restaurant, food and wine and hospitality markets. Listening to the discussions and introductions of some of Charleston's most popular chefs, I discovered my knowledge of gourmet cuisine has expanded significantly.

The media kit given to me at the luncheon listed all of the events, because of commitments with the kitchen remodeling project I chose to explore what I could at Marion Square while taking more photographs. I missed the grand finale, the BBQ, Blues & Brew on Sunday, a place to enjoy the best of barbecue and music and beer. Next year, I will make certain to leave the dates for the festival available so I can devote more time to this popular event. Meanwhile, I will write query letters to publications introducing next year's Food and Wine Festival.

Completing the task of transcribing all the notes collected at the Food and Wine Festival, I am ready to tackle e-mail. My inbox is constantly overflowing with SPAM, resulting in too many unread e-mails, too much garbage. Today, I will spend a couple of hours creating rules to delete many of these SPAMS, and to move writing related messages into a reading file, thus making my inbox more manageable.

Never will I make the mistake made a few years ago when I had the habit of replying to SPAM requesting them to unsubscribe me. Another step I take at least twice weekly is to run Symantec Anti Virus, and clean out my Internet Options located in the Control Panel. Working as a photojournalist, I must have a fast, dependable computer system.

LESSONS/PROBLEMS

If digital photography is your preference, make certain you back up your photographs on a regular basis. After downloading my images, I save them in a file on my hard drive, and I burn a copy on a CD, and place this CD in a file, labeled with the contents. Normally, I place a copy of this CD in my files of the subject matter. For example, all of my photographs from the Casa Marina Hotel and Jacksonville, Florida, are placed in the file titled Jacksonville, Florida. Individual subjects are copied to the stock lists folder.

PREDICTIONS

- *Follow up – research – query*
- *Prepare for weekend trip to Myrtle Beach at Travel South Showcase*

DIARY

Today is Wednesday. I have much to do to prepare for the weekend trip to Myrtle Beach. I am scheduled to attend Travel South Showcase, and I have many things to catch up on and plan before leaving, including where Phil and I will put all the customized cabinets scheduled for delivery on March 22. Frustrated with that reality, I decide to file those decisions away for a later time. I spent the morning at the Aquarium, taking some photographs of interesting fish and a boisterous parrot with a major attitude. I do not think he enjoyed posing for photographs.

Today, focus is difficult and I struggle with procrastination, something I rarely do. Working out of my home is difficult at times, simply because there is always much to do at home, especially now, with the remodeling project. I have managed to take a few more photographs of the demolished kitchen and will continue querying publishers for story ideas about kitchen remodeling.

I find myself questioning why I am going away to Travel South Showcase. What I have managed to do is to make a list of the pro and cons of this decision.

TRAVEL SOUTH SHOWCASE	
PROS	*CONS*
Networking	Need to be home due to remodeling project
Touring	Need time to work
Photography opportunities	
Schmoozing with writers, photojournalists	

I suppose if I took the time, I could find more negativity from my decision to attend Travel South Showcase, but considering the opportunities to meet with other professionals, Convention and Visitors Bureaus and other outlets, it is an opportunity I cannot miss.

For the professional photographer, networking is crucial. Now that I am a professional photographer and writer, I network everywhere I go. I have business cards in my handbag, in my car, and a box is in my husband's dashboard. Networking, along with marketing is the key to a successful career campaign as a photojournalist, and professional photographer.

Three months before I left the corporate world, I packaged a press kit and cover letter and sent it to the local Convention and Visitors Bureau in Charleston. When received, she phoned me and we had lunch together. During that time, I presented my goals to her and she arranged complimentary tours for me. When I get assignments in Charleston, or the surrounding areas, I always contact the CVB to request information and a visitors pass. Only once have I been

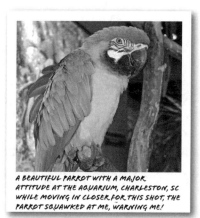

A BEAUTIFUL PARROT WITH A MAJOR
ATTITUDE AT THE AQUARIUM, CHARLESTON, SC
WHILE MOVING IN CLOSER FOR THIS SHOT, THE
PARROT SQUAWKED AT ME, WARNING ME!

denied assistance. The mission of Convention and Visitors Bureaus is tourism. These resources are valuable to you as a photojournalist and as a photographer. Not only do they go above and beyond to assist you, but their knowledge and resource of networks is unlimited. Since 2005, I have collected an entire notebook filled with business cards and personal contacts and when I need a resource for a story or a photograph, I can locate someone within reach without a problem. When I have a story or photograph published, I make certain they get a copy of the publication for their files.

Professional organizations include a variety of associations beneficial to a photojournalist.

LESSONS/PROBLEMS

The main problem I endured today was a lack of time to work and complete everything on my Things to Do

list. Interruptions appeared to happen almost hourly. The constant ringing of the telephone, arranging times, appointments, and weekly plans made me realize I need an assistant; however, due to budgeting concerns, I cannot justify adding the additional expense of an assistant to my business budget or marketing plans.

Making the decision to seek my dreams as a career photojournalist was a good decision and I have no regrets; nevertheless, I do wish the doorways to the higher paying markets would open soon. Every week is a marketing challenge, sometimes resulting in working into the late hours after Phil comes home, and awakening in the early hours of morning to meet my deadlines. Yes, it is a challenge, but I fully believe, it will be profitable soon. Working on this book and juggling the time to research markets is quite a chore, but it is my passion and I will continue this pursuit. I believe and practice the philosophy of "Good things come to those who wait, and persevere."

Day 11 *MARCH 8*

PREDICTIONS

- *Complete ten queries to publications*
- *Prepare for trip to Myrtle Beach, Travel South Showcase, scheduled for March 10-14*
- *Meet with Charleston Grill*

DIARY

The art of photography is sometimes capturing an image when least expected. Today was no exception. While driving across the Arthur Ravenel, Jr. Bridge, I noticed a brilliant sunset. I took a slight detour and rushed back to Patriots Point to seize the opportunity to capture the brilliance of the colors. The sunset photographs are awesome, especially with the shadows of the USS Yorktown, the cannons, and the spectacular golden hour of photography that I love so much.

Rarely do I travel anywhere without my camera, boating on the harbor of Charleston is no exception to this rule. In 2005, the Arthur Ravenel, Jr. Bridge opened. During the construction phase, I took many photographs of the process, in hopes to write a story about the building a bridge process. I published many stories and photographs about this stunning production, receiving a bit of fan mail on my website. Now that the skeletons of the Cooper River Bridge are gone, these photographs are an everlasting memory of the three bridges – Grace Memorial Bridge, Cooper River Bridge, and the Arthur Ravenel, Jr. Bridge.

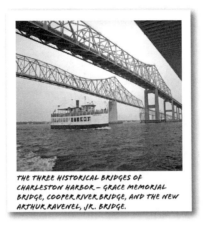

THE THREE HISTORICAL BRIDGES OF
CHARLESTON HARBOR – GRACE MEMORIAL
BRIDGE, COOPER RIVER BRIDGE, AND THE NEW
ARTHUR RAVENEL, JR. BRIDGE.

Capturing such photographs and preserving them, serves as a photojournalist history of many commemorative images that can only be illustrated through the beauty of photography. In future years, the memories of the historical, antiquated bridges will only be recalled via photography, the Internet, and the stories written. All of these media resources are to be appreciated. Without photographs to record special historical moments, many of the chronological moments of life would disappear. Photography serves as an expression of documented history. It is the profession of a photographer to bring these moments to life, to tell our stories through the emotions, compositions, textures, passions, and imagery composed in the viewfinder.

Today served as an extremely productive day as I managed to research ten markets for query letters for photojournalist submissions. In every submission, I mentioned digital

photographs were available. I targeted several construction publications, introducing myself, and I attached a few clips pertaining to construction, including three JPG files about tilt wall construction. I have accomplished a bit of success with construction publications and during slow times, or times when I have the inspiration, I will approach these markets. After all, construction photography is a market I have negotiated better prices (usually, I am paid $50 per photograph, and if it is a cover shot, the editors know my work and will pay what I request – my cover shots are normally $150.) While I recognize it could take at least three or four months to hear from these editors, I will await their response. Meanwhile, sending queries and marketing is truly my life.

I sent an e-mail to Mickey at Charleston Grill to discuss booking an appointment to see the completed renovations. He responded to my e-mail almost immediately stating he was booked with things to do and we would need to reschedule. This is a good example of the required follow-up necessary for success as a photographer. Life generates changes; appointments may need to be rescheduled. Flexibility is only one of the keys to success and since I could not meet with Charleston Grill, I chose to have a Plan B strategy by working on ten queries for this week, instead of the allocated five weekly queries.

LESSONS/PROBLEMS
Beginning March 10-14, I will be away from my home office at Travel South Showcase. This trip will result in early

morning meetings, tours and many, many events where I will not have access to a computer.

I am traveling with my laptop, although it is a bit antiquated and extremely heavy. I have ordered a new laptop and it is scheduled for delivery on March 23, so until then, I am a bit behind the times and when away from my office, not exactly productive. I must plan my wardrobe, read the literature about Travel South Showcase, and be prepared to make an impression.

I printed out several restaurant, accommodations, and tourism questionnaires so I can have them handy for interviewing.

My digital camera batteries are charging, camera equipment has been checked to make certain everything is in working order, new batteries for the flash attachment are packed and soon, I will drive to Myrtle Beach to network, meet new media, mingle and schmooze with friends and colleagues I have made in the industry, including photographers, writers, and travel tourism professionals.

Reviewing the information, I have discovered many southern CVBs, tourism boards, and travel destination professionals will be in attendance. This is my first trip to Travel South Showcase and I am certain it will be a productive event.

PHOTOGRAPH OF THE PIER AT JACKSONVILLE
BEACH, FLORIDA – TAKEN THROUGH A CHAIN
LINK FENCE.

Day 12 MARCH 9

PREDICTIONS
- *Back up files, especially digital photographs*
- *Prepare for trip to Myrtle Beach*

DIARY
Reading the materials sent to me for Travel South Showcase,
I am a bit confused. Although they have pre and post trips,
I have dedicated the past three months to marketing and
did not register for a pre or post tour. With the remodeling
projects at home, and a few deadlines approaching, I need
to have the time to check, recheck, proofread, and review
all of my assignments. I admit, I am a bit of a perfectionist
when it comes to my profession and I always analyze my
writing and photographs with a critical eye. Apparently,

I can always find something to change, not to mention allowing the self-doubts dance inside my head. The writing group tells me I am much too critical about my abilities and need to appreciate my talents. Gosh, is that hard for me! My photographs and my words are my babies. I labor over them with intensive care.

Back-ups of computer systems are crucial for all digital photographers and photojournalists. My local writing group and I have had this discussion a few times and many of them have suggested using tape back up systems, or simply saving all data on CDs. I have used a tape back-up system before and detested it. I make the attempt to save my files to a CD, but sometimes, with deadlines approaching, I forget to take the time to save or make a back up.

What happens if something happens to your computer and you see the blue screen of death? Did you do a back up? Did you save the files to a CD? If not, your data could be lost.

Failure to have a back-up system could result in the ending of a career as a photojournalist if the photographs are not preserved, so I do make an attempt to burn my photographs to CDs. Adobe Photoshop Services provides a digital back-up system, but I will be honest and confess I have not registered to do this. My husband is a computer engineer and when the mood hits him, he plans to set up a hard drive for me to save everything. Meanwhile, until I can afford a professional back-up system, I am working to burn my creations to CDs. Yes, it is time consuming and I use an abundance of CDs when I perform a manual back up. When I do this dreadful,

tedious task, I turn on the stereo and listen to some of my favorite jazz artists. Not only do I relax, but also the Muse of Creativity seems to flow with inspiration.

Today, while working on this assignment, I am doing a back up of the digital photographs I have filed. Effective today, I have exactly 11.7 GB of digital photographs in my computer system. Checking the Digital Iron Mountain back up plan presented by Adobe Photoshop Services, http://services. connected.com/adobe/plans.asp it would be quite expensive for me to register for this service at this time. Considering the benefits of this service, I will probably take advantage of this opportunity in the future, just to be certain I am managing my photographs in a more convenient method. My business is advancing now and with more time away from the office. With an increased workload of assignments, I will not have the time to schedule these backups soon, and definitely need a policy to manage this day-to-day operation.

Working as a professional digital photographer, I encourage you to create a strategic system to organize all of your digital files. My existing digital files consist of 6325 files, managed in 133 folders. No wonder I have nightmares of losing these images! Maybe I should consider paying for this service and have the backups scheduled on a daily basis.

LESSONS/PROBLEMS
Weighing the advantages of using an online service for back-ups could be a good idea; however, I will continue to use my system for now. I confess, I am a bit skeptical where online services are available.

While working on this assignment today, I opened my digital photograph file, only to discover many files have disappeared. How? Searching in my computer, the files were not in my recycle bin, nor were they anywhere else, with exception of the hard drive that synchronizes all the files. Working frantically with Roxio Easy Media Creator 7, I recover the files, copy the data to CDs (it took 17 discs) and I saved all the files to new locations. Lessons Learned! Always keep digital files backed up.

When Phil came home, I asked him to assist me, questioning how the files could 'disappear.' My computer system uses Symantec Anti Virus, Adware, and other software that is updated daily. I do not understand what happened, but I do find it strange that this incident happened while I am discussing how a photographer could be shut down and out of business if the images were lost.

Now that I am prepared to leave in the morning for Travel South Showcase, I am pleased that I sent my queries for this week in last week's batch.

Future considerations I will consider is to register with a service to back up my files, instead of doing it at home when I should be working on various projects. Lessons learned. I feel so fortunate that I did not lose those images!

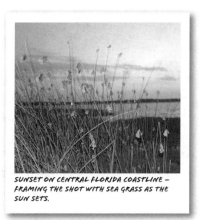

SUNSET ON CENTRAL FLORIDA COASTLINE – FRAMING THE SHOT WITH SEA GRASS AS THE SUN SETS.

Day 13 *MARCH 10*

PREDICTIONS

- *Drive to Travel South Showcase, Myrtle Beach, SC*
- *Meet with General Manager of hotel*
- *Register for Travel South Showcase*
- *Marketing/Networking*

DIARY

Today is the day. Travel South Showcase registration starts at 1:00 at the Myrtle Beach Convention Center. I left the house at 10:30, allowing extra time to stop and photograph items of interest. Yes, my digital camera is resting in the passenger seat, just in case I see something noteworthy to photograph. No, I do not take photographs while driving, but if I do see something of interest, I will exit the road, turn the car around, and find a place to park to shoot the images.

Photographing while driving is definitely NOT a good idea!

Driving on Highway 17 from Mt. Pleasant to Myrtle Beach (mostly trees, forest, and more trees) there is not much to photograph until I get to Georgetown. Before crossing over the bridge leaving Georgetown, I take an exit, park the car, and grab my camera. I am fascinated with bridges and find them interesting imagery to photograph repeatedly. This bridge is no exception because it has a marina next to it, with many attractive boats. Occasionally, I see seagulls and pelicans but today there aren't any within view. I take a close shot of the bridge, and jump back in the car. Next stop, probably Pawley's Island. Sometimes I see some characters strolling along the area, but today, there aren't any.

My mind is racing while I travel, and it occurs to me that marketing is an important tool for a photographer; however, to the novice who desires a career in such a path, perhaps marketing makes for an interesting topic to discuss.

Today is no exception. Packed in my portfolio are digital photographs, published clips business cards, and a brochure I will have available to any of the media professionals I meet, including the Convention and Visitors Bureau members, travel and tourism professionals, and other media I may meet. One of the most important rules for this industry is preparation – writers, and photographers must ALWAYS be prepared for the assignment. One never knows when a story could develop, either via imagery of photography, or current developments in the world.

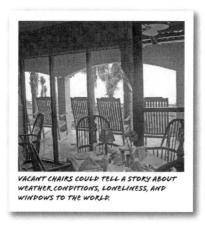

VACANT CHAIRS COULD TELL A STORY ABOUT
WEATHER CONDITIONS, LONELINESS, AND
WINDOWS TO THE WORLD.

As a photojournalist, I attempt to have my day planned, unfortunately, for the next four days, I will not have the capability to do that since my days are planned by Travel South Showcase.

Because I like to be prompt, I arrived at the convention center in Myrtle Beach at 12:30, the second person in line. Directed to the registration booth, I noticed signs for delegates, suppliers, and buyers. No indication of a line for media registration. At 1:00, I was instructed to go upstairs to the pressroom to register. Frustrated, I rush up the stairs, anticipating another long line, but was relieved when I walked in, registered, and left after collecting several press packets.

My room at the Marina Inn at Grande Dunes is amazing. The hotel is new, opening in November 2006. The entrance

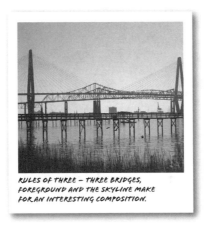
RULES OF THREE – THREE BRIDGES, FOREGROUND AND THE SKYLINE MAKE FOR AN INTERESTING COMPOSITION.

lobby has Italian tile flooring, columns, and high ceilings. The balcony has a beautiful view of the Intracoastal Waterway. This is a perfect location for a story idea and photographs since the hotel is new and I have one or two markets that could be interested in a story. Walking around the lobby, I shoot several photographs of the entrance, guest services, and other locations of the hotel.

Reviewing my itinerary, I have a busy schedule. Tonight we have a reception and dinner. Tomorrow, a full day of touring, meeting with tourist bureaus, and learning about the history of Myrtle Beach. I double check my camera, lens, memory cards, and batteries so I will be completely prepared.

LESSONS/PROBLEMS
Reviewing the schedule for the showcase leaves me a bit confused, since the media does not appear to have much

of a schedule for this event, at least not at the conference center. During the off time, I will use the time wisely by reading and meeting with the hotel staff. I have a tour arranged and I've taken several interesting photographs. Although a bit disappointed, I will make the most of my time; after all, this is my first time in attendance, and I am most appreciative of the opportunity they will provide. Scheduled for tonight is dinner at the hotel, and Myrtle Beach Theatre Night – It's Showtime. Unfortunately, we are not permitted to take photographs at the theatre, but they are providing CDs of imagery.

PREDICTIONS

- *Network with writers, CVBs, [Convention and Visitor's Bureaus] and other connections*
- *Marketing*
- *Review all information collected today, along with photographs*

DIARY

The event filled days at Travel South Showcase will provide much inspiration. Today starts early, with the bus arriving at 7:45 am. Since I do not require much sleep, it was easy to get up early, take photographs of the morning mist, the hotel, and await the bus. Sunday morning, March 11, we have a full day of tours, including Brookgreen Gardens, Cal Ripken Baseball Complex, Ripley's Aquarium – a VIP Behind the Scenes tour of areas not shown to the general public, including areas where injured or ill fish, sharks and turtles are cared for during convalescence.

What a photographic adventure Brookgreen Gardens is for a photojournalist. The sculptures are so beautiful, with each image poised to tell a compelling story of art, passion, inspiration, and beauty. Since we are traveling in a bus, I ask the bus driver to stop at the exit so we (the photographers on board) can take a few shots of the horse sculptures at the entrance.

We stop for a late breakfast at Murrells Inlet. Since I am not

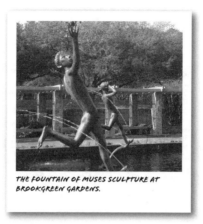

THE FOUNTAIN OF MUSES SCULPTURE AT BROOKGREEN GARDENS.

a breakfast eater, I excuse myself after drinking coffee to explore the bird's-eye view along the waterway. There are several statues along the walkway, most of them look real, and so I shoot a few shots. One of the statues that really caught my eye was of a pirate. Another cute image was of an African American male, dressed in a chef's jacket, sitting with his right leg crossed over his left leg, his head cocked, as if he is talking on a cell phone. Walking along the board walk, I see boats on the waterway, pelicans flying overhead, and the sky line is absolutely perfect. The water reflects the boat, and I click the shutter lots!

Travel South Showcase provides an abundance of networking resources. During meals, I introduce myself to new contacts, with business cards ready to exchange. I have collected over forty business cards, many from convention and visitors bureaus, hotels, restaurants, newspapers, the

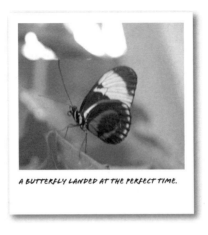

A BUTTERFLY LANDED AT THE PERFECT TIME.

department of tourism, resorts, theatres, and many more resources. If networking is the key to success in the business world, trade shows such as Travel South Showcase will certainly open doors.

Chatting on the bus with the other writers and photojournalists, I listen carefully to their stories about their working days, assignments and professional contacts, just to make certain my goals are on track. Most of the writers have been working full-time for over ten to twenty years. I find it a bit amazing how many of the writers are hesitant to journey into photography, and I discovered a surprising reality that not every writer is interested in photography. I am a bit envious that most of the professionals have been working this long in the profession, and I remind myself that persistence and determination, along with the right contacts will lead to stability and much work. There are thirty writers

on this trip. Only a handful of those in attendance [less than five of us] carry camera equipment on board the bus. I prefer sitting near the photojournalists carrying cameras and we brainstorm about the amazing world of photography. One man proclaims he worked as a photographer for National Geographic for a few years, but he is retired now and takes pictures just for fun. He appears to be quite serious, carrying a tripod and using it constantly. We have a married couple on board who are promoting their guidebook about I-95. Every piece of their clothing has an I-95 emblem on it. Rarely do I see them taking photographs of our tours and that surprises me. Their marketing tactics are quite creative, even their clothing has Interstate highway signs. Perhaps I was under the assumption that all writers are photographers. Not exactly true! I confess, I enjoy expanding my talents with the amazing fun and adventure of photojournalism.

Today has been a good day, busy, with lots of tours, and many photographic opportunities. Brookgreen Gardens was spectacular! The sculptures were stunning, and so were the gardens. Reviewing the images on my view finder, I am pleased with most of the photographs, although I cannot tell a lot about how good they are until I download the images when I get home. My laptop computer does not have the capability to do this and I cannot wait to get my new computer. Since my room at the hotel is located along the Intracoastal Waterway, I was able to shoot several shots of the waterway earlier, especially when I discovered a barge cruising along while sitting on the balcony.

LESSONS/PROBLEMS

With the convenience of digital photography, I am able to take photographs without worrying about running out of film. The only concern I have is the memory card getting full, or misplacing a memory card. I have several small bags in my camera bag reserved for memory cards, and I label one for used memory cards so I will not misplace them, nor install a card that is full into the cameras. I carry two or three memory cards on every shoot, in the event something goes wrong with a memory card, or in the event it fills to capacity. I have the tendency to click the shutter many times, in hopes I will capture an interesting image. Call me cynical!

PREDICTIONS

- *Queries – five to publishers*
- *Follow-up by checking query submission report, send follow-up letters*
- *Organize photographs from Travel South Showcase*
- *Reviewing Submission Tracker Report for Follow-Up*

DIARY

Travel showcases such as Travel South Showcase are exhausting! Meeting so many incredible people and making so many contacts is part of the travel and photography business. Today I am home, playing catch up! After a restful night of sleep, I am able to take on the task of playing catch up and I am amazed at how little mail I received while I was away. E-mail – too much – mostly SPAM! I am disappointed that no replies have arrived from any publications and hopeful that will change soon. Most writers I spoke with at Travel South Showcase stated they give publications a month or two to respond. I suppose now I should recheck all of my submissions to see who should get a follow up letter.

Reviewing my submission tracker report, I have a few queries I need to follow up on today, and I decide to see if I can locate e-mail addresses. For those I cannot locate an e-mail address, I will send a copy of the original query letter, and a follow-up letter.

Another item to add to my Things to Do list includes thank

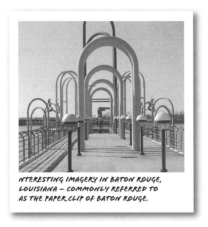

INTERESTING IMAGERY IN BATON ROUGE, LOUISIANA - COMMONLY REFERRED TO AS THE PAPER CLIP OF BATON ROUGE.

you letters to all of the people I met at the showcase. One never knows when (or how) this practice will help, and I must say, I've had some good responses by sending letters and a business card after these events. I find it a most valuable marketing tool!

The business of a professional photographer is much like a writer, either swamped with work to do, submissions, marketing and inquiries to respond to, or famine.

According to a recent newspaper article, there is a gallery located in downtown Charleston interested in representing the artwork of photographers. I phoned the gallery earlier today, speaking with the owner. He appears to be interested in looking at my work, so I will review the many files I have, print several of the images, make a CD and will check with the gallery to make certain that is all he requires for consideration. He was a bit evasive on the phone.

Another venue I plan to consider is to print several photographs as post cards and submit to local gift shops and consignment shops. There are many unique shops locally in Mt. Pleasant and in Charleston that could possibly be interested in taking on additional artists. This opens up a few creative marketing strategies for me. Why not contact local restaurants to see if they would permit me to hang a few 8 x 10s (framed and matted)? I thought about this idea tonight while at dinner. Collages of prints illustrating interesting angles of the Arthur Ravenel, Jr. Bridge were hanging on the walls in the restaurant, catching my eye.

"My images look better than that," I said to Phil. He agreed. While eating dinner we came to the conclusion that this could be another way to market the profession of photography.

Since the muse of creativity is flowing for me, I surfed on Google, under the subject matter of grants for photographers, finding 95 results. I have written several grants before, and I was the recipient of a local arts grants from the City of Charleston in 2004. I will review these web sites and apply for applicable grants. One of the advantages of grants is they are not considered loans, so they are not to be repaid; however, the requirements for consideration are quite extensive, including extensive applications, narratives, budget, credentials and applying for a grant can become a tedious task to write. Fortunately, I have experience with grant writing so I will review all and get the fingers dancing along the keyboard to apply.

LESSONS/PROBLEMS

Today was filled with many challenges, after attempting to play catch up all day. I spent the early morning hours downloading photographic images from the memory cards of my Nikon and Canon digital cameras, filing them in three different files and on CDs. I will reorganize them into separate stock list files at a later date – maybe on a lazy rainy weekend when I have nothing better to do.

In the late evening, with nothing interesting to watch on TV, I wrote five query letters to publications for photojournalism ideas. I continue telling myself, marketing is the key. Now, I must schedule time to write grants for photographic opportunities I hadn't considered previously.

Recently, I was walking in the forest searching for interesting images of wildlife. Woodpeckers are one of my favorite birds and I was hopeful to capture a few images of them. Listening carefully while walking, I heard woodpeckers and managed to locate one tapping his familiar tap, tap, tap on the tree bark. I zoomed in for a tight shot. Disappointed with the image, I played with it after downloading the images, discovering I could zoom in tighter with Adobe Photoshop. With the ease of computer software, I rarely delete any of my images, in hopes that with the proper photography software, I can manipulate the imagery into a productive and impressive photograph. I encourage anyone interested in a career as a photographer to learn as much as possible about the new art form of digital photography, along with the processing of digital photography.

PREDICTIONS

- *Research – Grants, Writing and Photography Opportunities.*
- *Review guidelines for grant applications for photographers, photojournalists*
- *Apply for the South Carolina Arts Commission Approved Artist Roster*

DIARY

With much to do, I review my Things to Do list and get busy. The deadline for the South Carolina Arts Commission Approved Artist Roster is approaching, with April 1 as the deadline. Knowing the arts commission, they will extend the deadline for those who procrastinate, but I will move forward with my application. They have a new online application available now, a program titled OSCAR (Online South Carolina Arts Resources) available to maintain the roster profiles and all information. Today will be a day to work on this application and I am glad that I have DSL access.

I do not enjoy working on an application online, although many arts and entertainment resources are moving towards modern technology. I find the task tedious and my eyes get extremely tired from looking at the monitor. Whenever I download professional or resourceful organizations online, I print a hard copy to use at a later time, or for reference. I suppose I still like a hard copy to read and refer to,

probably because I am a baby boomer, and hard copies of manuscripts and documents were a way of life for me while in school and as a younger woman. The downside of this is the hard copies increase the amount of files in a file cabinet, thus taking up room!

Continuing my research, I locate numerous grants available for photojournalists. Since I am a photojournalist, telling my stories with photographs and words, I will apply for some of these grants.

The Internet contains a wealth of information for everyone, including grant opportunities. Listed under the web site http://www.artheals.org/artist_support/grants.php is a complete listing of opportunities, including:

- A Room of Her Own Foundation
- Aaron Siskind Foundation
- Alexia Foundation for World Peace Annual Photography Contest
- Fifty Crows International Fund for Documentary Photography

The lists of organizations available to award grant funding are unlimited; however, when completing each application, I encourage applicants to follow the guidelines completely. Cater every application to that particular organization, checking, rechecking, and following all instructions. Make certain there are no errors in the application, including typos, grammar or punctuation errors, and all required information is included in the application. If one item is left out, this could be disastrous, resulting in a disqualification.

BRIDGING THE GAP AT GOLDEN EAGLE
COUNTRY CLUB, THE TIDES INN RESORT,
IRVINGTON, VA.

Most grant applications require a detailed budget with
the submission. Take the time to examine your submission
before mailing it. Allow yourself ample time to review the
grant application before mailing it. Grants require a detailed
thought process and lots of time to complete. Ask a friend
(someone you trust who will be critical) to review it and
make suggestions or comments.

I have completed a majority of the application for the
South Carolina Arts Commission with one exception; I must
include work samples, an artist studio, and a profile with the
application. Guidelines are available online for review and
I continue to review them. Before I send this submission, I
will print it, read it again and when I am pleased with my
application, I will click the submit button.

Although I have focused this entire book on photography

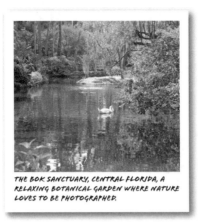

THE BOK SANCTUARY, CENTRAL FLORIDA, A
RELAXING BOTANICAL GARDEN WHERE NATURE
LOVES TO BE PHOTOGRAPHED.

and photojournalism, I would like to address another title of a professional photographer – the editorial photographer. An editorial photographer portrays a story through images and words, focusing on the emotions, textures and personal style of the photographer and the subject matter. Today while researching, I discovered a web site targeting the editorial photographer www.editorialphoto.com/outreachep. After reviewing the site, I applied for membership and feel confident I will be accepted.

Editorial photography covers an abundance of specialties from advertising to works of art and a variety of subjects and specialties. Since I have specialized as an editorial photographer, perhaps I shall reorder new business cards, listing myself as an editorial photographer, instead of a freelance photographer, photojournalist. I caution anyone to use the term freelance since the term freelance seems to

suggest my services as a professional photographer are free, and I assure you, my services are not free. Neither should you allow your photographs to be published for free!

LESSONS/PROBLEMS

Writing a grant application is something I would rather do in my leisure and working as a photographer and photojournalist, I have many deadlines to meet; therefore giving me little leisure time to pursue grants. The grant application for SC Arts Commission was a bit difficult to understand but I have sent it, and will hope for the best. Meanwhile, I have a print out of grant opportunities to pursue.

WRITERS AND PHOTOGRAPHERS ENJOY A
BEAUTIFUL AFTERNOON CRUISING ALONG
ST. AUGUSTINE, FLORIDA.

Day 17 MARCH 20

PREDICTIONS

- *Review images for story ideas with photographs*
- *Negotiation of fees*
- *Work on assignments due*

DIARY

After pushing myself too much, along with the hassle of remodeling, I took a much needed rest! Today I am spending much of the day reviewing my photographs with a critical eye. I have two assignments due, and the editors are still negotiating the terms of the photographs. One editor wants me to include the photographs, without a fee. I told her I am a professional and cannot give photographs for free. Her response was a firm, non-negotiable statement

that her publication NEVER pays for photographs. These discussions have all been via e-mail, so I have printed all the e-mails and placed them in the file for the assignment for future reference. My final correspondence, via e-mail to her was a firm, I do not work, or photograph for free, and from this point forward, I will not consider any assignments with her publication UNTIL we reach an agreement (and a contract) for negotiated fees for all photographs.

I consulted with a photography contact I have known for about a year, a true professional who never minds sharing his knowledge and expertise. He gets a considerable amount for his photographs ($250 each). Asking his advice, he encouraged me to quote my fees to the publication and stay firm, but because I need the exposure, I have suggested the terms of $50 each, and $150 if the image used is a front cover shot. Also, I have requested a contract. When finalized, I will submit an invoice with the proper fees. I am concerned that the publication will publish the photographs without my consent. I suppose this could be an important lesson I have learned – *NEVER, EVER* submit any photographs UNTIL a contract is completed. A valuable lesson I have learned!

Another editor requested my fees for the photographs to go with her story, so I followed valuable friendly advice. My fee was a bit more than another photographer friend gets for her assignments. When she started, she requested $100 for each image; I am requesting $150 for each photograph. I debated the fee over night, deciding not to change my rates. When I checked e-mail this morning, I got an e-mail from that editor, agreeing to the terms.

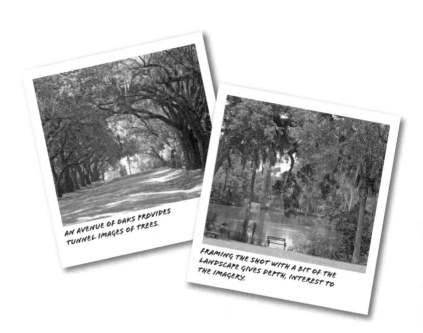

AN AVENUE OF OAKS PROVIDES TUNNEL IMAGES OF TREES.

FRAMING THE SHOT WITH A BIT OF THE LANDSCAPE GIVES DEPTH, INTEREST TO THE IMAGERY.

As for the other assignment, I am sticking to the terms I requested. I sent another e-mail to the editor, letting her know right up front that I do expect compensation for the photographs, and if she uses them without my permission, I will seek professional advice.

The publications I have mentioned only pay on publication date (POP) resulting in about a thirty-day delay from when the story and photographs hit the newsstands. Now, I am marketing more of the (POA) Pay on Acceptance markets. There is a lot to learn when you start out as a freelance photographer, and a photojournalist, and sometimes, I feel like I am learning things the most difficult way; however, when I speak with other colleagues, they share the same

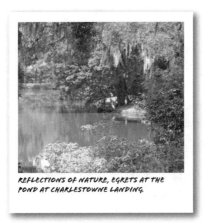

REFLECTIONS OF NATURE, EGRETS AT THE POND AT CHARLESTOWNE LANDING.

stories. I suppose it is all an educational process, but it is so frustrating when you must negotiate your rights and not allow the editors to compensate for free what the photographer deserves!

Perhaps these editors forget the amount of time a photographer spends just to get the right image. Maybe some photographers click and shoot, not caring for the right shot, but I take lots of time when shooting my images, and people probably snicker behind my back while watching me take a photograph. I imagine it is a bit comical because I will make an imaginary frame with my hands, looking through my hand viewfinder, just to see what the camera will see. Then, I place the camera into view, examining via the viewfinder, and if I am happy with the image seen, I will click the shutter. Other times, I will move to another angle, or tip the camera either up or down.

While reviewing my digital files, I would like to share a few of the tips I have learned as a digital photographer. I use a variety of filters on my digital cameras to filter the glare of bright light. Using a polarizing filter is ideal when photographing landscape and nature images. I keep filters attached to the camera lens, resulting in sharp images, especially when photographing outside.

If you have a digital camera that does not have interchangeable lens, or you do not have a polarizing filter, use a pair of sunglasses over the camera lens. Using a form of polarizing lens will result in enhanced images.

A question I am asked occasionally by friends is the importance of white balance. White balance is important in all forms of photography simply because the camera does not understand the difference in colors and hues. When I worked on film sets, I remember the cinematographer zooming in tight to a white screen to white balance the camera. My cameras are preset with a white balance value so I can get the proper colors and color temperature. Some lighting sources, such as fluorescent lighting will cast a shade of green lighting; therefore, I do my best to make certain my camera is white balanced. All of my digital cameras included an instructional booklet listing the importance of white balance. Take the time to play with the camera, and to read the instructional booklet and make certain to white balance your camera.

LESSONS/PROBLEMS

Reviewing so many of my digital files today, I recognize I must organize all of the files into separate files, pertaining to the subject matter, adding the entire selection to my stock lists files. It is most difficult to make an attempt to keep the images in my mind. Just what would I do if an editor or client requests an image that I know I have, but cannot find?

This will be a great project to do one afternoon or evening when I am exhausted, or have nothing better to do and simply want to take a day off. Maybe these are good projects to do, just when I want to kick back, relax, and play. Maybe I will pick the brain of photography colleagues to see if they have a smoother, more manageable technique in mind.

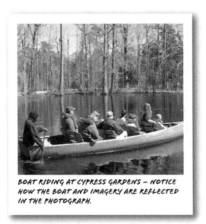

BOAT RIDING AT CYPRESS GARDENS – NOTICE
HOW THE BOAT AND IMAGERY ARE REFLECTED
IN THE PHOTOGRAPH.

Day 18 MARCH 21

PREDICTIONS

- *Photo shoot at Cypress Gardens located near Moncks Corner, SC*
- *Research*
- *Query letters – at least five to do*

DIARY

I phoned Cypress Gardens last week to set up a photo shoot for a travel guide I am working on. These travel guides are more marketable if photographs are included. There is always something more appealing when a visual image is included with the story or in a publication.

Cypress Gardens is located on the back roads of Moncks Corner, a rural area about thirty miles from Charleston. It

has many picturesque opportunities and is well worth the time to tour. The entrance is a bit misleading but once inside, the butterfly house exhibit, gardens, and the swamp, complete with alligators are lots of fun, and I shoot many photographs, including the birds.

I decide to take a boat ride. The guide volunteers to go with me, but today, I want to take my time and paddle along at my leisure. The swamps, cypress trees, water lilies, and wildflowers are absolutely gorgeous. Stopping for a moment, I see movement and I am able to look into the eyes of an alligator. I click many shots of Mr. Gator. I suppose he got offended, because he slipped back into the water. Hopefully he will not turn the boat over! Within minutes of his departure, I suspect I have grounded the boat when I feel something hard while paddling. Stopping, I place the paddle a bit deeper, only to see water splashing on me. Oops, I have found the alligator and feel I must get away!

After the refreshing boat ride, I rush over to the Aquarium and Reptile Center, stopping to take photographs of the exotic birds. They do not wish to be photographed today, and since these birds are in cages, I place the lens in the fencing, only to have the bird peck, peck, peck at the camera lens. I try to shoot his eyes, but he is too fast, so I consider it a lost cause and take a few shots of him standing away from the cage. I am not pleased with these shots, but will save them.

Arriving home in the late afternoon, I download the photographs, pleased with the swamp shots and the

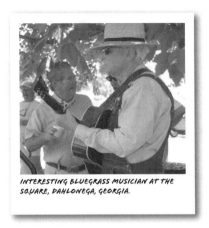

INTERESTING BLUEGRASS MUSICIAN AT THE
SQUARE, DAHLONEGA, GEORGIA.

photographs in the butterfly house. My favorite shot for today was the imagery of the paddleboats along the dock. The swamp water reflects the cypress trees and the boats giving the imagery a nice mirror image. Sometimes I am most pleased with my work!

I review my query submission report, deciding on five query letters to prepare. Two story proposals will go to food and wine markets, discussing the Charleston Food and Wine Festival, the remainder are stories I need to get published, including hospitality-focused stories about Beaumont, Texas and Baton Rouge, Louisiana. Since I am targeting new markets, I print out my resume and two clips to include with the query letters and get them ready to mail tomorrow morning.

The photographer friend I mentioned previously looked at some of my pictures once sharing his knowledge. One

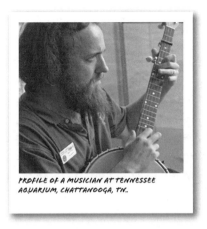

PROFILE OF A MUSICIAN AT TENNESSEE AQUARIUM, CHATTANOOGA, TN.

valuable piece of advice he shared was before shooting a photograph, think about the subject matter, and go in tight, especially "go for the eyes," if the subject has eyes. I have always remembered his advice and I cannot tell you how much it has helped me to become a better photographer. When I focus on photography, I always whisper to myself:

1. What is the subject?
2. Before shooting, inhale, exhale, hold your breath, and then click the shutter. This practice has helped me to decrease *shaky camera syndrome*.
3. Go for the eyes. If the subject has eyes, zooming in tight to shoot the eyes can reveal lots of emotional content.
4. Move in close. If photographing people, move two or three steps closer to the subject, fill the frame, and click the shutter. Go for the facial expressions.

5. Frame the shot.

Although it sounds like a lot to remember, if you focus before clicking the shutter, your photography will improve dramatically.

LESSONS/PROBLEMS

Not enough time today to complete all the research for additional query letters. I wanted to prepare a total of ten queries. I will add this to my Things to Do list for tomorrow. I suppose some people could say today was not a productive day for me since I failed to get all the research completed for the query letters; however, any day where a photographer gets some good, successful images, is definitely a good day. I can work this weekend, if needed to get, and stay on track. I consider today a most productive day since I got some terrific images at Cypress Gardens.

PREDICTIONS

- *Early morning review of query letters and research*
- *Writing a grant*
- *Reviewing the South Carolina Arts Commission for grant opportunities*
- *Reviewing The New Digital Photography Manual to comprehend some technical aspects of digital photography*

DIARY

Starting the morning off with research, I am reviewing online grant information for photographers and photojournalists. There are numerous grant opportunities including:

- A Room of Her Own Foundation, established for women writers and artists, A Room of Her Own Foundation is a non-profit organization designed to further the visionary efforts of writer Virginia Woolf. The organization was formed in 2000 and works to provide opportunities for women artists and writers. http://www.aroomofherown.org/home.html

- Aaron Siskind Foundation – targeting photographers with interest in still photography, based upon accomplishments, according to the web site. Check the web site for additional information and to review the career of Aaron Siskind. http://www. aaronsiskind.org/news.html

- Other resources to consider for grant opportunities are the abundance of arts commissions for every state in the United States of America. Most states do have a regional state arts commission, and it could certainly be beneficial to get to know these people. I have met with the SC Arts Commission professionals and I am convinced it is important to become familiar with them.

- Alexia Foundation for World Peace Annual Photography Contest – provides funding for a photographer with compelling picture stories to promote world peace and consideration of the cultural diversity. Visit the web site http://www. alexiafoundation.org/ for extensive information about the grant process.

- South Carolina Arts Commission – reviewing their website, I see the potential for a grant, so I encourage all artists to contact their local arts commission for these opportunities. Today, I will review and complete an application and decide what images to submit.

- Getty Images for Editorial Photographers – www. gettyimages.com/editorial-grants - after reviewing this site, I wrote a detailed proposal and completed it since the deadline is approaching. Tomorrow it will be mailed!

Switching gears for a bit, I decided to start the organizational process of managing all of my digital files. I

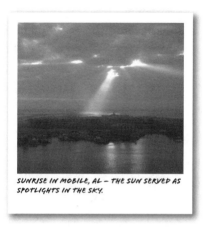

SUNRISE IN MOBILE, AL – THE SUN SERVED AS
SPOTLIGHTS IN THE SKY.

will search in each file noting the subject matter, and move
the images to additional files labeled with the images, and
to my stock lists. For example, for shots of birds, I have built
a file labeled Birds. Then I will build another file for Nature
shots, Landscapes, Butterflies, and so forth. By organizing,
labeling and moving the images to these files I will be able
to find the digital images in a more manageable method.
Eventually, this will work better for me and I am hopeful that
when I have more knowledge about Adobe Photoshop, all of
my digital files will be easier to find and access.

I purchased a book about digital photography a few weeks
ago. *The New Digital Photography Manual* by Philip Andrews.
I am hopeful it will walk me through the learning process
of Adobe Photoshop a bit quicker than other books I have.
While glancing through the book, the chapters appear to
be interesting and easy to comprehend. I confess, I am

not a technology expert and prefer to find an easy 1-2-3 approach, but the more I learn about digital photography, the more I want to learn, so when I have a few days to relax and not be stressed with deadlines, I will use the time wisely and read the book while playing with the cameras.

LESSONS/PROBLEMS

Gosh, how the day flies while working at home on the computer. Most of my friends say they would not stay disciplined to work at the computer if they were home; however, working at the computer is not a problem for me. I sit here so much, my butt feels almost glued to the desk chair.

Today, I worked so diligently on the management of digital files, I failed to find the time to research query letters, so I am saving that for a later date, probably this weekend. Working as a career photographer, editorial photographer, photojournalist, or additional descriptions of the work I do, I find the task are tedious, but rewarding, especially when the checks and rewards roll in. Yes, it could be described as an isolated life, but for me, it is my passion.

PREDICTIONS

- *Queries – five targeted, ready to go*
- *Work on my blog*
- *Study The New Digital Photography Manual*
- *Researching digital photography web sites on the Internet*

DIARY

Today is Friday and there is much to do. I spent the morning working on my blog, adding photographs and a few stories I have written. My blog is targeted for the photojournalist. I have not placed many photographs on it, but as I continue updating and writing it, I am certain I will. Today while reviewing it, I have made a few notations about what would make it more interesting and I do believe, a few digital photographs would add much. I do not claim to be a webmaster, nor do I have the patience to manipulate a web site. I do not understand the technology. I am a photojournalist, not a webmaster guru!

After my work out at the gym, I came home, completed five queries, sending the following query letters to magazine editors:

- Preserve Our Heritage – the Downfall of Textile Mill Villages in America
- Blue Ridge Mountain Territory
- Girlfriends Getaway Vacations
- Hiking in the Woods

- We've Got it All Here in Daytona Beach

These queries were selected because I have not heard from the other outstanding query letters, and these have been in the hands of publications for six months. Some of the stories and photographs published previously have taken six months or longer without a reply; however, after following up, if I don't get a response, I start the process all over again. Such is the case today.

The query letters introduction always starts with the first paragraph of the story idea, and I include a listing of a few photographs. While I do not include the photographs in query letters, I do mention that I have digital photographs available, and I list something significant about the photographs in the letter, for reference. Now that my stock lists are organized, it will be much easier to locate the appropriate images.

Submissions to magazines takes such a long time for a response, meanwhile, I am working on printing some of the digital photographs, matting and framing a few and getting them placed in gift shops. Other ideas I have scheduled are completion of all the grant applications, submit the photographs to the gallery downtown, and I still have this book to complete, so my days are busy.

The temptation is so strong to hire an assistant, but where would an assistant work in all of this remodeling disarray? It takes about eleven weeks to complete the remodeling of the kitchen. Today is March 23. The cabinets were delivered

yesterday and today Home Depot is coming to check them. The installation is scheduled for Monday, so for the next week or longer, I will have too many interruptions in my workday.

Since the kitchen remodeling is fresh on my mind, maybe I will spend a bit of time today organizing those photographs. I have one file for the demolition process and I am certain I will take a few of the cabinet installation.

Checking e-mail, I got a surprise. An editor is interested in a story idea I pitched to her a few months ago, a story about Diabetes. Although I have no photographs for this story, I can certainly use the assignment so I sent her a reply and will add this assignment to My Things to Do list.

After mailing the letters, I read a chapter in the book *The New Digital Photography Manual,* recognizing it is a good, informative, and illustrative reference for a novice photographer and for someone who wants to increase their skills.

At two o'clock, I was interrupted by the telephone. Reaching for it without checking to see who was on Caller ID, I was surprised to discover it was the editor who refused to pay me for the photographs. She is still interested in the story; however, without the compelling photographs, she will probably have to kill the story. I was most diplomatic, listening to her then I chose to have my say. I ask her if it was a practice for advertisers not to pay in her publication. She replied that advertisers are the glue that holds the

publication together. Recognizing I would probably lose her as a client, I emphasized how good my photographs were, and how she rarely had to edit my stories since they were well written, meeting her and the publications needs. Still, I informed her, I expect to be compensated for the photographs. The conversation continued for about fifteen minutes or longer with a final decision to kill the story *kill the story is a term used in publication circles, meaning the story will not be published.* Now that the story is in the *kill process,* I can submit it elsewhere. Another task to do – researching markets for this particular hospitality story!

After that lengthy conversation, I chose to play on the Internet, researching digital photography web sites. There are many to review. Typing the key words of *digital photography web sites* on Google, I hit 12,800,000 sites.

LESSONS/PROBLEMS

Days of much confusion since the kitchen cabinets are stacked everywhere in the house. We cannot open the front door due to a coffin sized cabinet boxed, and pushed flush to the front door. We have boxes in the living room, boxes resting opposite my desk, boxes in the kitchen, boxes in the foyer, and boxes blocking the front door. No doubt, these interruptions will decrease my productivity, so I will spend this time working frantically on this book, and organizing digital photography files. I wanted to work and play with Adobe Photoshop, but I will place that idea on the back burner.

WINDOWS SERVE AS INTERESTING METAPHORS FOR PHOTOJOURNALISM.

Day 21 *MARCH 24*

PREDICTIONS

- *Catching up – backup of computer system, follow up for marketing purposes*
- *Organizing photographs and story ideas*
- *Working on my Blog*

DIARY

While driving home today from my work out, I noticed the skyline and was amazed at how interesting the colors were. An overcast day with the sun fighting to break through the thick clouds, I found myself thinking about photography. No matter where I go, or what I do, I am always thinking about camera angles, interesting images, and the old cliché of "This is a Kodak moment."

FACIAL EXPRESSIONS SAY SO MUCH WHEN THE MOMENT IS RIGHT!

There are many *Kodak moments* in our lives. Working as photographers, editorial photographers, and photojournalists, we become almost obsessed with our cameras, regardless where we are, or what we do. We click shots in anticipation of telling a story through images from our cameras, and we analyze our work with critical eyes.

While walking in downtown Charleston, I found myself taking photographs of the sidewalks, especially those that are so antiquated, in need of repair. These photographs could serve as good story material for an editorial about compliancy of the American Disabilities Act, and the reluctance of tourist locations to fulfill the strict codes.

Another story idea I have dancing inside my head is a story about the homeless in America, and how tourism locations such as Charleston respond to the reality of homeless

SMOKING AT KEY WEST.

characters strolling along the streets. I have several images in digital files and will research markets later. The reality for story ideas is something exciting for me, and I am never lacking in material to pitch to publications. The images of the homeless characters in our cities and towns tell such a compelling story created by pictures, and few words and I find it difficult to get this discovery out of my mind.

Now that I work as a photojournalist, I am always thinking with a camera in mind, looking for story ideas and opportunities in the most bizarre situations. I suppose that could be the disadvantage of my life as a writer, photographer. It is difficult for me to enjoy vacations, boating, family visits, entertainment, and sporting events without my camera.

Today, I researched more photographic assignments,

sending letters of introduction to several organizations, including the local Chamber of Commerce. Although I am not a member, I would like them to have my press kit in their possession. In the press kit, I included a letter of introduction, current resume, and clips of my stories, mentioning in the letter that all photographs in the stories belong to me, as the photographer. While I was at Travel South Showcase, a director of marketing for one of the companies in attendance mentioned that she recently paid a photographer $3,000 for a collection of photographs on their web site. When she reviewed my photographs, she shared this bit of knowledge, mentioning if she had known of my work, and me she would hire me for the project. Her reaction stayed with me and I decided to pursue this venue. After all, I am a photojournalist. I can shoot the images, and write the stories.

In the afternoon, I have a problem focusing on my work, so I decided to work on my blog. Before posting anything on my blog, I write the ideas and storyline in Microsoft Word. I suppose this is because I am accustomed to writing in Microsoft Word and it is my comfort zone. I make a file titled Writing Blog and all documents are saved in this folder, along with the photographic images I will use to add to the story. Now that story ideas are flowing, I will use this day to bring the stories and images to life, and later, when I have quiet, and not so much disarray, I will post the items on my blog.

After completion of these tasks, I researched photography guidelines on several writing market sites I use, made several

notes of five of the publications I want to contact, and did a back up of my system. Since I am a photojournalist, I research markets on a weekly basis, and the more I achieve with photography, the more confident I am that my shots are of the quality and professionalism publications require.

LESSONS/PROBLEMS

With the installation of kitchen cabinets scheduled for Monday, I am rushed to prepare everything. The house is prepared – with boxes everywhere. All of this disorder makes for additional clutter that I would like to throw out. I find it extremely hard to focus now, but I am certain the reality of deadlines, query letters, marketing, and backing up my computer system will return.

SHALL WE DANCE? ANOTHER EXAMPLE OF WHY PHOTOGRAPHERS CARRY CAMERAS. INTERESTING IMAGES, METAPHORS OF OUR LIVES ARE EVERYWHERE, INCLUDING DOWNTOWN ASHEVILLE, NORTH CAROLINA.

Day 22 MARCH 27

PREDICTIONS

- Starting the week off right – getting queries done
- Research photography assignments
- Preparing new query letters, photographs
- Kentucky story and photographs

DIARY

Some days the best laid plans are filled with interruptions. Today is no exception because of the installation of the kitchen cabinets. I took yesterday off, due to the noise and constant pace of disturbances. I managed to read a bit, studying marketing and research opportunities for

photographers, and I heard from Editorial Photographers. I am now a member. I posted my credentials and membership profile on the web site, and I am hopeful that will be another successful and profitable link.

Today will be a productive day, even with the interruptions, phone calls, and hassles of working at home. I completed five query letters and will mail them in tomorrow's mail. Meanwhile, I am researching while reading an informative book that every photographer should have within reach. I purchased the 2008 edition of *Photographer's Market: Where and How to Sell Your Photographs.* This instructive book is filled with valuable information for photographers and photojournalists. If you are serious about your success, this book is certainly the major resource you should have on your bookshelf. Included in the book is a chapter about Getting Started, Running Your Business, with great information, photographs and Markets, Grants and Professional Organizations. *Photographers Market* is one of the series published every year by Writer's Digest Books. Visit the website www.photographersmarket.com to sign up for a free newsletter.

Reviewing my calendar of Things to Do, I decide today is a great day to work on the Kentucky project. Fortunately, the story is almost complete; however, since it was written about six months ago, I must double check all information, statistics, contact information and I will make many long distance phone calls verifying everything. The editor sent an e-mail to me, attaching the contract and guidelines. The word count for the story is 1700 words. She did not

limit the amount of photographs. My rule of thumb is to include a CD with the story, containing the story (without photographs) a contact sheet, and approximately twenty images.

I opened the file of digital images, noting several I can use. Now, I must spend some time reviewing what image will go where, and how many to include. Building a new file, I add twenty-five images to the CD. The deadline for this project is not until mid July, but I prefer to get these assignments completed ahead of time. My reputation is built on never missing a deadline and I am certain I will make this one without a problem.

Today is a day of self-discovery. While working on the story for the Kentucky magazine, studying the photographs carefully, I recognize my photographs are telling the story with few words, thus I recognize I am a photo essayist. Now what exactly is a photo-essayist? If I had to define the term, I would say it is a photographer who is serious about shooting compelling images, to tell a significant story. This is a euphoric moment for me since I am a writer and haven't always taken my photography seriously until recently. One thing I have recognized is how I always go for the emotions, or personality of a photograph. I tell my subjects to be candid, not posing for the camera, and I always strive to catch my subjects at a compelling moment when they are not focusing on the camera, but being themselves. I work with the framing, posturing, body language, the lighting, especially natural lighting, and I do my best to capture the moment or the message conveyed in a photograph. Today,

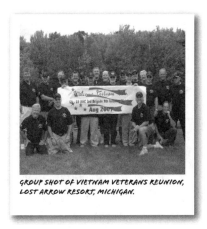

GROUP SHOT OF VIETNAM VETERANS REUNION,
LOST ARROW RESORT, MICHIGAN.

while reviewing over 200 images for the Kentucky story, I recognize I have a new passion. I can tell a story without words, through my photographs!

LESSONS/PROBLEMS

Too much happening today with the kitchen renovations and I question why I chose not to move away until the renovation was completed. Practically speaking, I had to be realistic and frugal with the household budget; however, I cannot stop asking myself how productive I could be if we rented a hotel room during the renovations. Considering the high cost of hotel rooms, I must be realistic while juggling the budget. Until I have a steady flow of assignments, a budget must be followed. Fortunately, today was spent researching and I am learning more about career opportunities as a photojournalist, editorial photographer, including commercial photography, wedding photography,

and opportunities working with the school system. For now, I like the combination of writing and photography, so I will target more photo essay markets. Like negotiations, creativity is the key in this career.

Another valuable lesson I learned today is the voice and theme of self-discovery as a photo essayist. Previously, I mentioned the availability of photography in my queries as a convenience for the editor, thinking it would be easier to sale a story with photographs included. I suppose I failed to consider that photographs can tell a story because they are visual, something the readers can relate to, a tangible entity to identify with. I suppose today has been truly a day of growth for me because I can share my photography with story ideas, and I can stand firm to negotiate the fees I, as a professional digital photographer, so deserve.

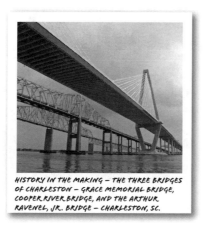

HISTORY IN THE MAKING – THE THREE BRIDGES OF CHARLESTON – GRACE MEMORIAL BRIDGE, COOPER RIVER BRIDGE, AND THE ARTHUR RAVENEL, JR. BRIDGE – CHARLESTON, SC.

Day 23 *MARCH 28*

PREDICTIONS

- *Research tools and equipment for photographers*
- *Review of Travel South Showcase photographs*
- *Query letters – results of Travel South Showcase*
- *Research – Dahlonega, GA*

DIARY

I started the morning off with fresh, hot coffee and a review of the photographs I took at Travel South Showcase. Working in the media entails a bit of schmoozing, along with tons of marketing. Based on this fact, I always introduce myself to the Tourism Offices, Chamber of Commerce, Parks, Recreational and Tourism officials, and of course, the Convention & Visitor's Bureau. Today is a day of following

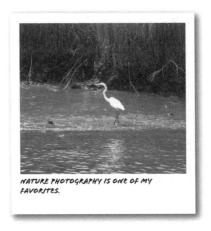

NATURE PHOTOGRAPHY IS ONE OF MY FAVORITES.

up with these officials, by finalizing the thank you letters, business cards, and a personal request to be placed on their preferred media lists. When finished, I will have letters to the following states:

- Director of Alabama Bureau of Travel & Tourism
- Director of Arkansas Department of Parks and Tourism
- Director of Visit Florida
- Georgia Department of Economic Development
- Kentucky Department of Tourism
- Louisiana Office of Tourism
- Mississippi Development Authority
- North Carolina Department of Film and Tourism Development
- South Carolina Department of Parks, Recreation and Tourism
- Tennessee Department of Tourism and Development

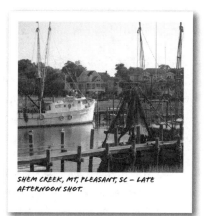

SHEM CREEK, MT. PLEASANT, SC – LATE AFTERNOON SHOT.

- Virginia Tourism Corporation
- West Virginia Division of Tourism

While working on the letters, I decide to organize a selection of digital photographs to include on a printed contact sheet, so each personal contact will be able to see my photography skills and talents. Personalizing each letter, I mention to all that I have a new photo essay assignment about Kentucky scheduled for publication in September. Referring to upcoming assignments does help to show media resources the writer of this letter is serious about her profession.

I finalize thirteen letters including a letter to the director of Travel South Showcase, and mail them. I believe people still enjoy getting a personalized letter, instead of a cumbersome e-mail of thanks, so I like to do this in a timely fashion. Yes, it takes a bit of time to personalize the letters; nevertheless, the

result could lead to additional marketing success.

Brewing a fresh pot of coffee, I research photography equipment and tools, just to make certain I am on top of the latest and greatest technology available. While I have a variety of lens for my cameras, I do not have the Canon EF-70-200. Based on the price of it, I cannot justify the expense until I get more stability with the business, and I am certain I will. All in time. I re-emphasize I have been working full-time as a photojournalist, photo essayist for less than two years, and this business is highly competitive; nevertheless, when I can, I do plan to invest in additional professional lens and this one is definitely a lens I desire to have.

In the evening, I pull e-mail before shutting the computer down, to discover I have been invited to travel to Dahlonega, Georgia in early May. Dahlonega is truly a precious gem of a town to call home, a pleasant place to visit, entertain, and learn about Georgia vineyards, destination weddings, the discovery of gold in 'them thar hills,' blue grass/mountain music, and the best of small town America. According to the research I read, Dahlonega has 42 privately owned restaurants. Population is 5000+, 34,000 combining the city and county. The Town Square is old fashioned, with signs posted telling drivers pedestrians have the right of way. A small town with much to offer, this could be a great opportunity for me to photograph the vineyards, mountains, people, destination wedding locations and so much more. I respond to the invitation, and accept this opportunity. The more I read about Dahlonega, the more I get a bird's eye view of the photography and

photojournalism opportunities I will discover. I am familiar with the area, since I grew up in Georgia, so I am certain when I tour, I will feel right at home.

Reviewing the remainder of my business calendar for 2007, I have appointments booked for mid June, July, August, and September. Two of these bookings (August and September) consist of group photo shoots for non-profit organizations. The booking in August is for a military reunion. September's shoot consist of a convention. Before I go on site to shoot a location, I like to have a bit of background so I will have an idea of who, what, and where I want to shoot.

LESSONS/PROBLEMS

Today was the day for research since there was so much commotion inside the house. A good day to read research, update my business plans, catch up on all correspondence, and think about themed portfolios. When I complete the organization of all of my digital files, no doubt I will have many portfolios available.

PREDICTIONS
- *Research Stock Agencies*
- *Proposals/Press Kits to Advertising Agencies Locally*

DIARY

Perhaps today will be a productive day since the cabinet installation is temporarily completed, until the corrected, defective cabinets are delivered. I managed to take a few photographs for the tentative, proposed story about Remodeling 101, and since I am focusing on that story, perhaps this is the perfect setting to discuss Focus – not just with the camera, focus on the chosen career as a photographer. After I created a business plan, I decided to create some marketing strategies and other components to reach the status of a professional and successful photographer.

My focus today is to work as an editorial photographer. Not only am I a photographer, I am a writer who tells the story with words and images. My focus is a specific focus, targeting the travel, food and hospitality industries, and I love to take photographs of nature, especially wildlife, landscapes, and sunrises and sunsets.

One additional strategy I have established on my business plan is to establish a few networking resources with stock agencies.

Stock photo agencies are representatives providing a variety of photos to their clients, including advertisers, periodicals, and other companies or resources that need photographs. These agencies retain a portion of the sales collected, while paying the photographer a percentage. Before signing with a stock photo agency, research to make certain of the marketing methods of the agency and make certain you understand the terms of the contract. With the ease of researching on the Internet, it is easy to discover a variety of ways to market your photo stock. I have not signed with a stock agency and the more I research on the Internet, the more I realize it might be easier for me to share space on a web site.

I suppose I am a bit skeptical about placing my photographs live on the Internet, since I am fearful someone will copy, or steal the photographs. While thinking about this, I decided to send an e-mail to two of my photography friends, one who serves as a mentor for me and pick their brains.

Reviewing the website for the Charleston Chamber of Commerce, I have decided to target some of the advertising and PR firms and submit a press kit to them introducing my professional services for copywriting, marketing, and photography. Local markets are a good way to increase revenue and to market professional services, so today is the day. Included in my press kit is a printed Contact Sheet of local photographs, clips (a term used for photocopies of published stories and photographs), resume, and a fees schedule. I place these items in a twin pocket portfolio, include a business card, and mail ten of the press kits in the

afternoon mail. I will continue this practice for a few weeks to see how much interest is created.

Checking e-mail again (seems I am a bit addicted to it) I get an auto reply from one of my photography contacts. He is away for at least a month, working on a shoot in Africa. I click on his site, and admire his images. I decide it is time for me to finalize stock agencies and not to be so fearful of someone stealing my photographs.

LESSONS/PROBLEMS
Today was a busy day, writing query letters, revising a few for submission later, and reviewing information about stock agencies. Marketing is such a tedious task. Among the resources a photographer needs to tap into include:
- Advertising Markets
- Stock Agencies
- Galleries
- Art Fairs
- Photography Competitions
- Publications
- Public Relations
- Photo Representatives

No doubt, if a photographer considers all of these excellent networking devices and uses them, the amount of time required will diminish the time to take photographs. Since I continue to stress the importance of marketing, I will contact a few of these sources just to see what happens. My Things to Do list is quickly growing!

Day 25 *MARCH 30*

PREDICTIONS

- *Organizing clips, credentials*
- *Reviewing matting and framing ideas*
- *Meeting with Michael's Arts and Crafts for suggestions, expertise, ideas*

DIARY

Today is Friday, a time to catch up on all that I have not completed this week. I have spent the majority of today researching different marketing venues, choosing to work on my clips, portfolio, and credentials. I plan to start the process of contacting photo representatives within the next few weeks. I came to this decision after reading articles in photography magazines, and reviewing the market of photo representatives listed in the current *2008 Photographer's Market.*

Another task in progress is the organizing of photography folders, portfolios and stock lists. I have decided that from this date forward, I will take two hours weekly just to review and organize the images into folders labeled with the appropriate subject. Sometimes the freelance business is truly nerve-racking. Deadlines approaching. Marketing. Staying on top of a business plan. Organizing.

Another issue I attempted today was playing with Adobe Photoshop. I confess, it intimidates me! I purchased the *Photoshop 7 All-in-One Reference for Dummies,* and the

LAKE PONTCHARTRAIN VINEYARDS – THIS PHOTOGRAPH COULD TELL AN INTRIGUING STORY.

more I read it, the more I realize I must take a class. Adobe Photoshop offers so much for the photographer, including Painting, Drawing, Working with Layers, Channels, and Masks, Retouching, and so much more. It will take me until the next millennium just to learn all the advantages of this program. Maybe I will go back to just being a photographer, and not worry about all the software packages available for digital photography.

Needing a break, I drive to Michael's Arts and Crafts Store in North Charleston. I introduce myself to the manager of the matting and framing department and we exchange a conversation about framing some of my prints. I am collecting information now, which will help me to decide what photographs I want to matt, frame, and solicit at gift shops and galleries locally. The month of May, I have scheduled on my calendar to complete this goal and I want

to collect as much information as possible to have my tasks reach accomplishment.

Since matting and framing photographs professionally is so expensive, I am considering taking a course at Michael's so I can compare prices, and have the correct knowledge and expertise to make certain my images are of the professional quality I desire.

LESSONS/PROBLEMS

A day of frustration with interruptions and so many things to do, just to continue with my business plan and goals. I still have not heard from any of the queries I have sent and I am getting a bit concerned. This is another example of why I believe I should consider photo representation or stock agencies. I want to move my business to the next level of success and I will stop at nothing to do that!

In a small way, I thought working as a photojournalist would be so much fun, and it is thrilling when I am working with my digital cameras, capturing just the right imagery. Nothing pleases me more. What I do not enjoy is the highly competitive business side of photography – compiling proposals, the marketing, following up, sending invoices, organizing files, backing up equipment, along with the other demands of the business world. While it is true, I enjoy meeting with clients, showing my work, and giving them advice, I do not enjoy the negotiation process. I find it difficult to quote the prices since I am fearful other competitors will cut my pricing, and they do.

To end the hassles of a day filled with disappointment, I drove to Alhambra Hall, capturing several photographs of the Arthur Ravenel Jr. Bridge, children playing, and the golden hour of sunlight. Noticing the sun was setting over the harbor, I drove to Patriot's Point and took several photographs of the sun setting and the harbor. I must say, Patriots Point, Waterfront Park, and Cypress Gardens in Moncks Corner, are three of my favorite locations to shoot. I suppose this is the beauty of living in such a popular tourist destination. Charleston is such a beautiful city to photograph. Her lights, colors, style, culture, history, beaches, and her passion are a photographer's dreamland to shoot.

Within the next few months, I plan to visit locations closer to Kiawah Island. One particular location I want to add to my portfolio of Charleston stock is Angel Oaks. Located on Johns Island, a rural, but booming area near Kiawah, Angel Oaks is a magnificent historical tree that is reportedly over 1400 years old. The tree branches sweep back into the ground and up towards the Heavens. Filled with Spanish moss, Angel Oaks gracefully extends her tree branches out like an octopus, embracing all who visit.

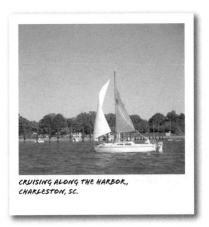

CRUISING ALONG THE HARBOR,
CHARLESTON, SC.

Day 26 *APRIL 2*

PREDICTIONS
- *Invitation to press trip to New York and Ontario*
- *Correcting Photographs in Adobe Photoshop*

DIARY
A most productive day. Today I wrote five query letters to magazine publications for stories about Alabama, Central Florida, Charleston, South Carolina, Beaumont, Texas, and Durham, North Carolina, mentioning the availability of digital photographs for all story ideas pitched. Additionally, I wrote five letters to photo editors, pitching story, and photograph ideas, suggesting that I have a stock of photographs available for their perusal, including nature shots, landscapes, beach and nautical and restaurant and

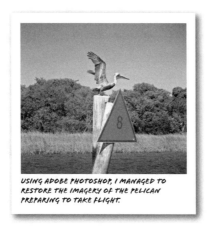

USING ADOBE PHOTOSHOP, I MANAGED TO RESTORE THE IMAGERY OF THE PELICAN PREPARING TO TAKE FLIGHT.

hospitality stock shots. Now that I have my marketing goals set for the week, I will focus the remainder of this week on photography and the business of photography.

While cruising on the Charleston Harbor, my camera bag was ready for action. I clicked several shots of the Charleston Harbor, the Arthur Ravenel, Jr. Bridge, and some intriguing shots of seagulls and pelicans.

Arriving home, I downloaded the photographs to my computer, placing them in Adobe Photoshop. Unfortunately, about twenty of the shots turned out as blackened images. Examining my camera, I discovered while shooting these images, I had accidentally moved the camera mode, resulting in a black screen. Remembering the images of a pelican posing, I wanted to correct the photographs and was determined not to lose anything.

Ah – the beauty of Adobe Photoshop. Although I am not well versed with it yet, I managed to manipulate it enough to retrieve the blackened images I had considered deleting. Deciding to experiment by using the Auto Smart Fix icon I was able to restore these images to an acceptable quality, and I learned a valuable lesson about checking my camera, just to make certain I have the correct mode set.

While checking e-mail today, I got an invitation to attend a press trip to Niagara Falls and Ontario Canada. Scheduled for June of this year, I am considering accepting this invitation. I applied for a passport in early February, so it should arrive in time for this trip.

Working as an editorial photographer and a travel writer, I get invited to an amazing amount of press trips to cities and special events, especially now that I am pursuing this career on a full-time status. Most of the trips I decline, especially after reviewing my photo shoot schedules, and queries that I need to follow up on. If I accepted all of these invitations, I would not have the amount of time available to market the photographs and stories. Another consideration I implement is to think about where I can place photographs and stories, based on the press trip invitation.

Many publications do not accept photographs or stories resulting from a press trip. As a professional, I am obligated to do all that I can to get a story or photograph published. Reading the guidelines for each publication consumes a lot of time for the photographer and photojournalist.

Because I have over 100 queries out now, I have to schedule time to write stories, assign photographs, and locate the correct assignments. This is a tedious task. Nevertheless, the invitation for Niagara Falls is much too tempting and I feel confident I can locate the proper markets.

The e-mail invitation states reporters and travel writers with assignments are preferred. I review the e-mail again, deciding to respond with a few clips and an updated resume. I mention that I do not have an assignment, but I will start the marketing process. Two hours later, I receive a reply from the Convention and Visitor's Bureau thanking me for the reply and they would love to include me in the invited VIPs scheduled to attend. She thanks me for being so honest with her about not having an assignment, and she compliments my tenacity, saying that my track record speaks for itself. What a nice comment. I recorded the dates in my day timer and I am pleased that the summer will be filled with many interesting photographs and story ideas.

LESSONS/PROBLEMS

This could have been a disastrous day, all to the credit of my failure to check my camera equipment before using it. While clicking the shots of the pelicans and seagulls in flight along the harbor, I failed to take the time to check my images with my viewfinder. A valuable lesson learned, and another reason why I am enjoying digital photography so much. Years ago, those blackened images photographed while using the incorrect mode, would have resulted in nothing for me to use. Fortunately, with the software packages of digital

photography, I was able to retrieve and restore the images into some nice photographs. Thank you, Adobe Photoshop! I must learn more about your incredible software.

AIMING FOR THE EYES AT THE MARDI GRAS MUSEUM, ALABAMA, PROVIDED AN INTRIGUING CHARACTER AT THE ENTRANCE.

Day 27 *APRIL 3*

PREDICTIONS
- *Sending files to editors, or photo buyers*
- *Meeting with clients, assistants*
- *Photo shoot for local architect*
- *Downloading, Organizing photos from the photo shoot*

DIARY
Today was a day of scheduled meetings and location shoots to a construction site where I took several photographs of three homes for an architect. He has hired me to photograph three custom homes he designed for clients and he is entering these homes in a national competition. Unfortunately, the agreement was a Work for Hire agreement, meaning twenty of the images belongs to him

and I cannot submit them to anyone else. Since the pay was considerable and he met my terms without any negotiations, I agreed to his Work for Hire terms. Many photographers would tell me I should not agree to Work for Hire contracts; however, when the pay scale is better than most of the work I commission, and the subjects were images I normally do not do, I agreed. I will receive credit for the photographs, and that is another credential to list in my portfolio and resume.

When I arrived at the three locations, the assistants for the architect were waiting on me. (One home is located in a resort community in prestigious Kiawah Island, another in Sullivan's Island, and the last home is in Hilton Head.) I thank each of them for their time and expertise, and then I explore the different angles, settings, and placement of all furnishings in the three customized homes. Since these homes are 'model homes' they are decorated and staged properly. Nothing is in the way and all of the homes are vacant. Entrance areas and traffic areas are effective and this makes an easy arrangement to photograph the homes. I shoot several interior shots of the grand entrance of each home, the gourmet kitchens, master bedrooms, winding staircases, architectural structure, windows, ceilings, and other extraordinary areas, including the stonework, swimming pools, gardens, and a master suite at the Sullivan's Island location. One of the houses has five garages, so I took a landscape shot of it. The home in Kiawah has a gigantic, gourmet kitchen with an island that must be six feet long, hanging pots, and track lighting. If only I could

afford to hire an architect to design a home, this is the dream floor plan of the kitchen of my dreams! This architect has such an eye for detail, glamour, and elegance. His homes make such interesting images, with lots of windows.

Arriving home late in the afternoon, I download the images from the camera, place them in Adobe Photoshop, and write the captions for the selected images. According to our agreement, I need to send the architect twenty images, so I work on the selection of the best photographs, burn a CD and submit an invoice. This was an easy shoot, with no one in the way or to bother me.

I spent the remainder of the day checking and cleaning the Inbox of Outlook, and working on query letters to a few publications, including two story ideas I have ready to mail for publications looking for story and photograph materials about Mobile, Alabama and Texas. I have several interesting images from press trips and want to find markets for them.

After the competition expires for the custom homes, I will probably approach the architect about a photo essay idea I have dancing inside my head. Checking e-mail, I read an e-mail from one of the advertising agencies I contacted via U.S. Mail. He is interested in meeting with me to discuss a copywriting assignment he needs written. I check my calendar and discover next week I am busy, but I will arrange a time to meet with him. Meanwhile, I surf the Internet to review his company, their goals, clients, and to learn a bit of their history. The agency has been in business since 1978 so they are an established company. I will contact

him via e-mail to discuss a few ideas I have and to book an appointment. I will remind him I am a digital photographer and can assist him with the media portions of his clientele.

LESSONS/PROBLEMS

Although a busy day with lots of location shoots, I am exhausted and energized to do more. I will spend most of tomorrow playing catch up, organizing and responding to e-mails, and perform a bit of follow up on queries I have not heard from. Reviewing my query submission report while watching the TV, I have about twenty follow-up letters to write. Another thing to add to my Things to Do list is sending the photographs to the architect, and writing a detailed description of the homes at each location. The word count for each is only 500 words, so that should not be too difficult. I plan to focus on the gourmet kitchens and the Art Deco architecture.

REFLECTIONS DURING THE GOLDEN HOUR ON AN OVERCAST DAY IN BATON ROUGE, LA.

Day 28 *APRIL 4*

PREDICTIONS

- *Follow up – Submission Query Report*
- *Soliciting photographs in gift shops, specialty shops*
- *Reprint of a story and photographs – Hiking My Dreams at Grotto Falls*

DIARY

Awoke early, ready to take on the task of following up on submissions and organizing photographs. When I complete this, I will review business forms photographers might consider, including the Release forms, contracts, and other documentations needed to assist with the business side of photography.

Success finally! The submission query report is current, with all the following-up for the queries right on track. I shall give these publications two months, and if no response, these queries will go to additional markets.

Another day of research where I discovered several stunning images suitable for framing, including one I took in Baton Rouge, Louisiana. Taken during sunset at a swamp in the bayou, the moon was breaking through the clouds, reflecting in the swamp. I titled this compelling imagery as *Moonlight on the Bayou of Louisiana*. I plan to meet with local gift shops to offer a few local framed photographs on consignment to place in their shops. I organized these images into a Stock List File, creating another file titled Gift Shop Images. One of the merchants I met with recently is interested in my photographs, especially a few of the Arthur Ravenel, Jr. Bridge and some additional shots of the Lowcountry of Charleston. She expressed additional interest in an image of the bayou of Baton Rouge, stating she belongs to a group that is assisting Louisiana with recovery from Katrina. This is just another way of demonstrating one never knows what a patron, customer, or merchant is looking for when it comes to photography. Art is in the eyes of the beholder.

When checking my e-mail in the afternoon, I received an e-mail from a publication asking if they could have the reprint rights to my story, *Hiking My Dreams at Grotto Falls*. The editor stated she read it in a magazine and wanted to include it in her publication. I replied, to let her know I did have the rights now and could grant her request.

Meanwhile, since she failed to mention the fees, I let her know what I expected. I suggested including three additional photographs I had not submitted to the other publications and I mentioned this would be the third time the story is published.

LESSONS/PROBLEMS

A productive day busy with the details of organization and follow up. I plan to spend more time on a weekly basis organizing files and updating the stock list of all digital images. Perhaps one day in the future I will discover an easier way to organize them, and I am hopeful that day will arrive soon. I get sleepy moving and organizing files. I suppose it is because the images are constantly moving and my eyes are readjusting at such a fast rate. On the other hand, maybe it is because sleep deprivation is keeping me tired.

PREDICTIONS
- *Meeting with Advertising Agency in downtown Charleston*
- *Organizing digital photographs into stock files, a never-ending process!*

DIARY

At 9:00, I left the house for a 10:00 meeting downtown with the advertising agency. Because Charleston is always a city filled with major traffic congestion, I want to make certain I arrive early. Downtown parking is extremely limited so after I drive around East Bay Street a couple of times, hoping to find a parking spot on the road, I decide it is best to park in the garage.

The agency is located in an old historical building on East Bay Street. A courtyard is in the rear. A restaurant located on the corner. I introduce myself to the receptionist and give her my business card. I feel like a patient awaiting medical treatment and I anticipate she will invite me inside so the doctor will see me. Sitting in a plush micro fiber chair, I double check to make certain everything is organized. I have an extra press kit, printed contact sheet of local photographs, two resumes, tape recorder, and a notepad ready. I glance at my watch, realizing that is a part of body language I do not wish to reveal, so in anticipation, I wait. The door opens and I am greeted by a young, handsome lad, looking more like a young attorney than an advertising

professional. He extends his hand, invites me inside for a cup of coffee.

We make small talk for a few minutes. Feeling confident in my surroundings, I offer my press kit to him. He opens a file, shows me he has reviewed my web site, clips and he proceeds to tell me the nature of our meeting. He has a film project coming up in six months and is establishing a crew of professionals to work with. He noticed on my web site that I have a background in film as a screenwriter and wants to know if I would be interested in working with him on this project and others. My responsibilities could be many, including working with the producer, assisting with script continuity and still photography. Based on the project, he needs a quote from me, and he wanted to meet with me personally to highlight the potentials of the project. We ended our conversation by stating he would call me in one week and let me know what my duties would be. He mentioned the possibility of working on a script and since the script must be completed before production, he would like to consider me for a bit of still photography.

This is definitely an opportunity I could contribute to and I am certain I could do a professional job. I am thankful the company plans ahead and does not wait until the last minute like many of the companies I have worked for in the past conduct their business. Our meeting lasted two hours and I left feeling I had made an important professional contact.

I treat myself to a well-deserved lunch downtown at Basil

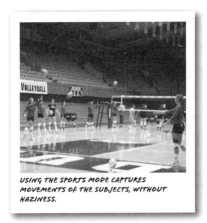

USING THE SPORTS MODE CAPTURES MOVEMENTS OF THE SUBJECTS, WITHOUT HAZINESS.

Thai Cuisine restaurant. Awaiting my food, I organize the notes from the meeting. Although the information mentioned above covers the conversations of our meeting, I reorganize the notes since they were written in a shorthand that only I can comprehend during meetings. When taking notes, I never write with vowels, using mostly two letters each for the notes. Because of this habit, I like to restructure my notes while they are fresh in my mind.

After completing the task of organizing digital photographs into several stock files, I chose to spend the remainder of today collecting resources to query. I was amazed to discover how many subjects I have collected and compiled into digital photographs and now that I have enough stock, I plan to generate another major marketing campaign.

Reviewing my submission query report, I wrote follow up

letters to twenty magazines, inquiring about a decision of the story and photograph pitches I submitted two months ago. Getting replies from these queries has been a major problem, even though I encourage contacting me via e-mail or telephone. Some markets state it could take up to four months or longer to receive a reply. Working as an editorial photographer definitely requires a mountain of patience.

When submitting my query letters for assignments as an editorial photographer or photojournalist, I always review the guidelines of the publication, following them to the letter. Before mailing, I make certain to include:

- CD of images, if applicable, following the guidelines of the publication.
- Enclose a SASE, self addressed stamped envelope
- Include a one-page letter, resume, clips, and my business card.
- Address the letter to a person. Editors change positions repeatedly, so be certain to confirm who the photo editor, or appropriate person is, along with the proper title. Many times, I will phone the receptionist of the publication to get the appropriate party. I do not ask to speak with the editor, because I know they are extremely busy working on approaching deadlines.
- When packaging, I generally package and mail the contents in a priority mail envelope. I use the flat rate envelope, enclosing a business size SASE for their reply. While it might be a little more expensive to use the priority mail envelope, for my needs this is my preference.

- Follow up – periodically, send a letter of follow-up for all major submissions, and include post cards with digital samples.

One of my business mentors suggested recently that I research the Small Business Administration for business management tips and general information, including grants offered, especially the grants for women entrepreneurs.

LESSONS/PROBLEMS

A day of much activity and potential for me. Following up with correspondence to magazines and other publications is getting to be a major, time-consuming task. Even though we are in the Twenty-first century now, I am still a bit skeptical of e-mail correspondence and sending attachments, especially when submitting query letters to the higher paying markets. I still use the snail mail method, most of the time, unless the guidelines prefer e-mail correspondence.

Today, while surfing grants on the Internet, I reviewed the Small Business Administration web site discovering a new grant available and will need to add this to my Things to Do list since the deadline for grants proposals is May 30.

PREDICTIONS

- *Wrapping up this journal*
- *Response from publications regarding query letters*

DIARY

Checking e-mail early this morning, with a steaming cup of coffee, I am ready for the day. This morning is starting off great. I have three e-mails from regional publications responding to my query letters. One of the publications would like me to send a stock list. Another publication requested the story and photographs. Since she failed to mention the fees, or if they pay for photographs, I will respond to her inquiry after I research the guidelines. When I have my homework done, I will send an e-mail to her, confirming that she is a paying market. I will confirm that she does pay for photographs, and I will request the photography guidelines and pay scale. If not suitable, another e-mail will request negotiations, based on my credentials and expertise as a professional photojournalist and photographer. I do not plan to waste any more time on magazines that do not compensate for photography!

I do not wish to repeat the mistake I made a few weeks ago when I sent the photographs to a different publication I will not publicize. Although one of those photographs made the cover of the magazine, the publication was not a paying market. After discovering that reality, I sent an

A WINDOW OF OPPORTUNITY, FUN, AND RECOGNITION AWAITS THE PROFESSIONAL PHOTOGRAPHER.

e-mail to the editor to let her know I could not include photographs without pay in my story submissions. Funny, I have not heard from her in quite a while. Just goes to show, success is all about marketing, and the FREE in freelance DOES NOT IDENTIFY me as a *free* photographer. My theory is if my photograph is good enough to make the cover of a magazine, I should be compensated for it – not in additional copies of the magazine, as she suggested, but financial compensation. Think about it – how many times have you picked up a magazine because the cover photograph caught your attention?

Many photographic professionals I have met are amazed with the amount of credentials I have accumulated in such a short time of working as a photographer and photojournalist. While it is true, I have only been working as a full-time editorial photographer, photojournalist for less than one year, before I chose to work full-time in this

industry, I was moonlighting. Perhaps that reality assisted me with a few contacts and resources to continue the pursuit of my dreams. I am a member of several professional organizations, including International Food Wine and Travel Writers Association [IFWTWA] and recently becoming a member of the Editorial Photographers organization. I fully believe in networking and encourage anyone to market and network, regardless of your career pursuit.

Photography is a highly competitive industry; nevertheless, if you have the eye for photography, and you can market yourself and your images, there are many professional paths you could venture into, and be successful. The achievements of today are only a few reflections due to the success and recognition of a steady marketing campaign.

Later in the day, I received a response from another publication in response to a query letter I submitted online. According to the editor, the query letter got lost in a computer glitch and she wanted me to submit it again. This story is about grandmothers who are still dancing to their own tune. The editor stated she loved the premise and wanted to pitch it at an editorial meeting. She reassured me she would let me know when the story was accepted. All she needs from me is the query, and my resume. Things are looking up!

Reviewing my work for today, I realize communication and personal attention results in achievement. My customer service and personal interest in my clients has assisted me tremendously. Whenever I take a photograph of a client, I

always encourage them to act natural, not stare, and smile straight into the camera. I want to capture the emotion of the subject matter, the essence of the moment, along with the personality, and I zoom in tight, shooting for the eyes, to capture the essence and personality of the subject, not a stale and cold smile. Before shooting a photograph of a person, I strive to get on their level.

I encourage the client to get comfortable and to act natural. If the event is a wedding, or significant event, I encourage the client to forget that I am taking photographs. Most of my photography is for publication in hospitality, food service, and travel magazines, so most of my images are taken during assignments, a FAM [Familiarity trip] or an arranged, commissioned trip. When taking photographs at a restaurant, I stroll around the area, and if I see an interesting person, I will ask permission to take their photograph. Also, I get permission from the kitchen staff to enter, and to take photographs of the kitchen staff (and the Chef) while in production. I suppose I have been fortunate because I love people and I enjoy capturing their comfort zone, not a stiff pose.

LESSONS/PROBLEMS

Today has been a major day of accomplishment. The e-mail I sent to the publication to confirm their pay schedule for photographs resulted in a quick response with the current photography guidelines attached. I am thrilled that in one day I have contracts for three publications, and today is the final entry for this career diary.

OTHER CAREER DIARIES

Career Diary of an Animation Producer
Sue Riedl
ISBN: 1-58965-011-5

Career Diary of an Animation Studio Owner
Joseph Daniels
ISBN: 1-58965-010-7

Career Diary of a Caterer
Jennifer Heigl
ISBN: 1-58965-031-X

Career Diary of a Composer
Patrick Smith
ISBN: 1-58965-024-7

Career Diary of a Dental Hygienist
Nancy Aulie
ISBN: 1-58965-042-5

Career Diary of a Marketing Director
Christa Bahr
ISBN: 1-58965-045-X

Career Diary of a Newspaper Reporter
Hamil R. Harris
ISBN: 1-58965-033-6

Career Diary of a Publication Design Director
Leon Lawrence III
ISBN: 1-58965-030-1

Career Diary of a Social Worker
Diana R. Hoover
ISBN: 1-58965-034-4

Career Diary of a Teacher
Carol Anderson
ISBN: 1-58965-035-2

Career Diary of a TV Production Manager
Craig Thornton
ISBN: 1-58965-015-8

Career Diary of a TV Show Host
Author: Hilary Kennedy
ISBN: 1-58965-044-1

Career Diary of a Veterinarian
Christine D. Calder
ISBN: 1-58965-043-3

Career Diary of a Vocalist
Nikki Rich
ISBN: 1-58965-037-9

Career Diary of a Web Designer
C. R. Bell
ISBN: 1-58965-022-0

Available at bookstores everywhere. For more information on these and other titles in the Gardner's Guide Series visit www.GoGardner. com.